Portrait Drawing
for Kids

PORTRAIT DRAWING
for kids

A Step-By-Step Guide to Drawing Faces

Angela Rizza

ROCKRIDGE
PRESS

For general information on our other products and services or to obtain technical support, please contact our Customer Care Department within the U.S. at (866) 744-2665, or outside the U.S. at (510) 253-0500.

Rockridge Press publishes its books in a variety of electronic and print formats. Some content that appears in print may not be available in electronic books, and vice versa.

Interior and Cover Designer: Eric Pratt
Photo Art Director/Art Manager: Tom Hood
Editor: Natasha Yglesias
Production Editor: Ashley Polikoff
Illustrations: Angela Rizza

ISBN: Print 978-1-64152-725-5 | eBook 978-1-64152-927-3

R0

Dedicated to my grandparents John and Martha Leone, who started me on my art journey, and to my parents for supporting me through it.

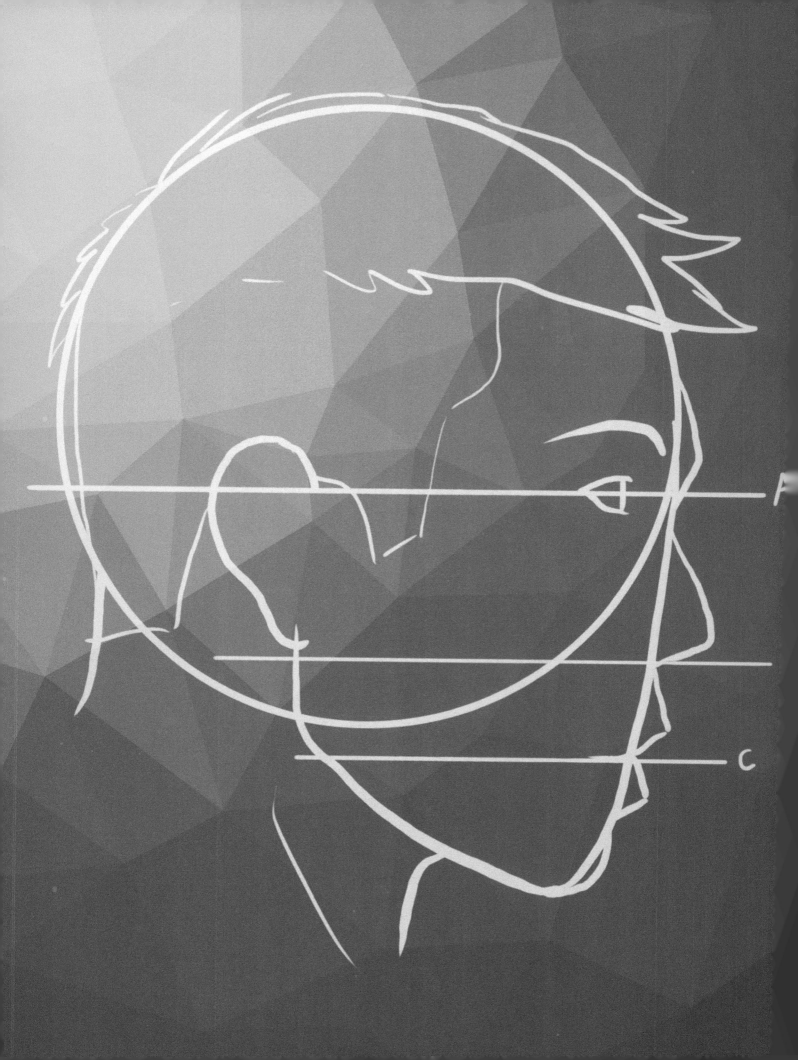

CONTENTS

INTRODUCTION

Hello, budding artists! Guess what: The selfie isn't just a modern-day thing! Throughout history, people have wanted portraits of themselves. In ancient civilizations, kings had their likenesses carved into statues and painted onto walls for all to see. Throughout the Renaissance, the wealthy had their portraits painted and hung in their homes as status symbols. And for hundreds of years, artists have been sitting in front of mirrors, capturing their reflections.

A selfie is a moment in time captured. It's a way to catch a memory of someone and keep it forever. A selfie can communicate who a person is, wordlessly. As an artist, you can draw how you or your friends want the world to see you and your story. No one is alike, so let's use this book to celebrate our uniqueness. By being open to our diverse world and observing its humanity, we elevate our art.

It can be easy to feel overwhelmed by illustrations in books and think you can't draw anything similar. I don't want you feeling that way, so I've broken down the drawings in this book into simple steps. And don't worry, nothing you draw has to be perfect. Your first few drawings may not look exactly as you intended, but remember that nobody learns without making mistakes, trying new things, and leaping out of their comfort zone.

Go at your own pace. If you feel like redoing an activity before moving on to the next, that's totally fine. Drawing should feel like fun, not like work.

Ready? Let's go!

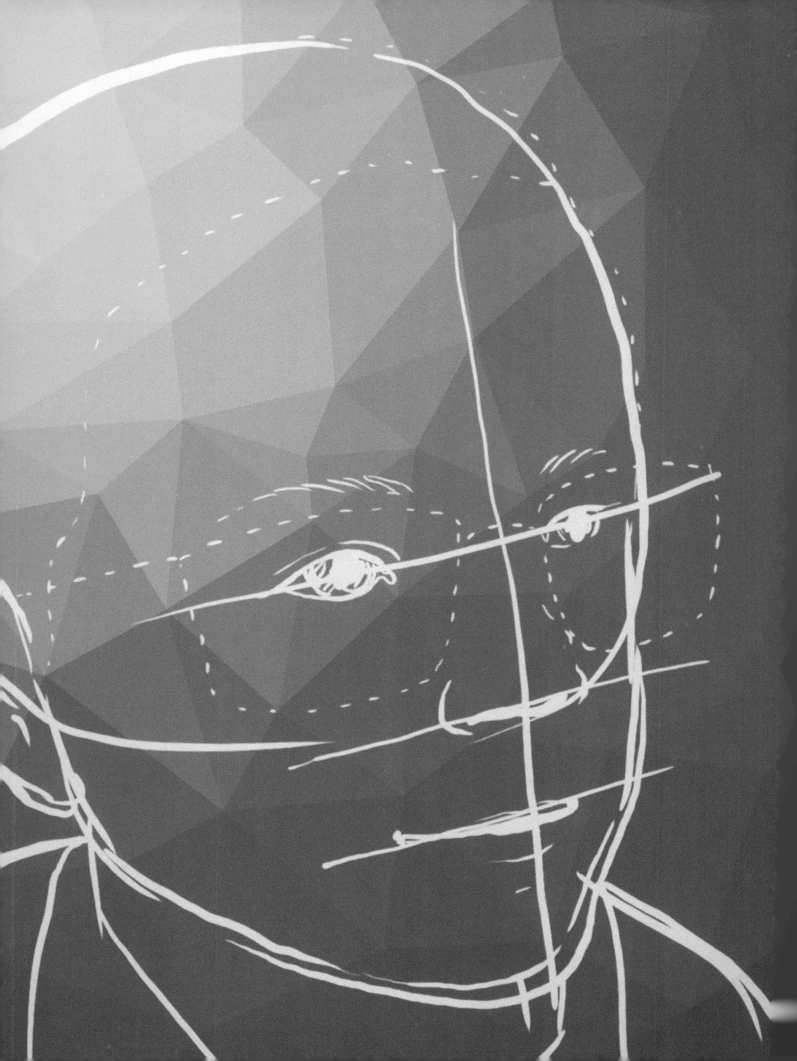

FOR TEACHERS AND PARENTS

In my previous book, *Figure Drawing for Kids*, space constraints meant I couldn't include everything I wanted to say about drawing faces. In this book, I'm able to expand that lesson. I discuss drawing portraits young and old, facial features, expressions, subject posing, and self-portraits. Kids can use lessons from my previous book—such as the portrait chapter—as a foundation, then go into detail with this book. This is my second how-to book and is based on the past decade of working as an illustrator and private teacher. I include foundation lessons I learned while getting my BFA at the Fashion Institute of Technology in New York City, as well as lessons I've developed through teaching art to elementary and middle school children.

In this book, I break down facial structures. I give a brief lesson in drawing basic foundational forms, and then provide step-by-step activities that touch on drawing more than just generic shapes. Faces are unique, and I hope to challenge young artists to draw what they see rather than to simply follow traditional formulas. The key to drawing a successful portrait is to capture someone's likeness, and to do that, we need to move beyond drawing an oval for an eye or a circle for a head.

I use a variety of subjects because the world is filled with an array of people and styles. I want to capture the likenesses of people you might see every day on the street, and not the academic or idealized depictions found in most books or magazines.

The goal of this book isn't to teach kids to copy images, but rather to get them to learn from the lessons and apply them to their future illustrations. The goal is to teach kids to look at and celebrate, through their creativity, what makes people different from each other. After following along with the lessons and activities, kids can take their newly attained knowledge and expand on it to create their own comics, graphic novels, paintings, drawings, and beyond.

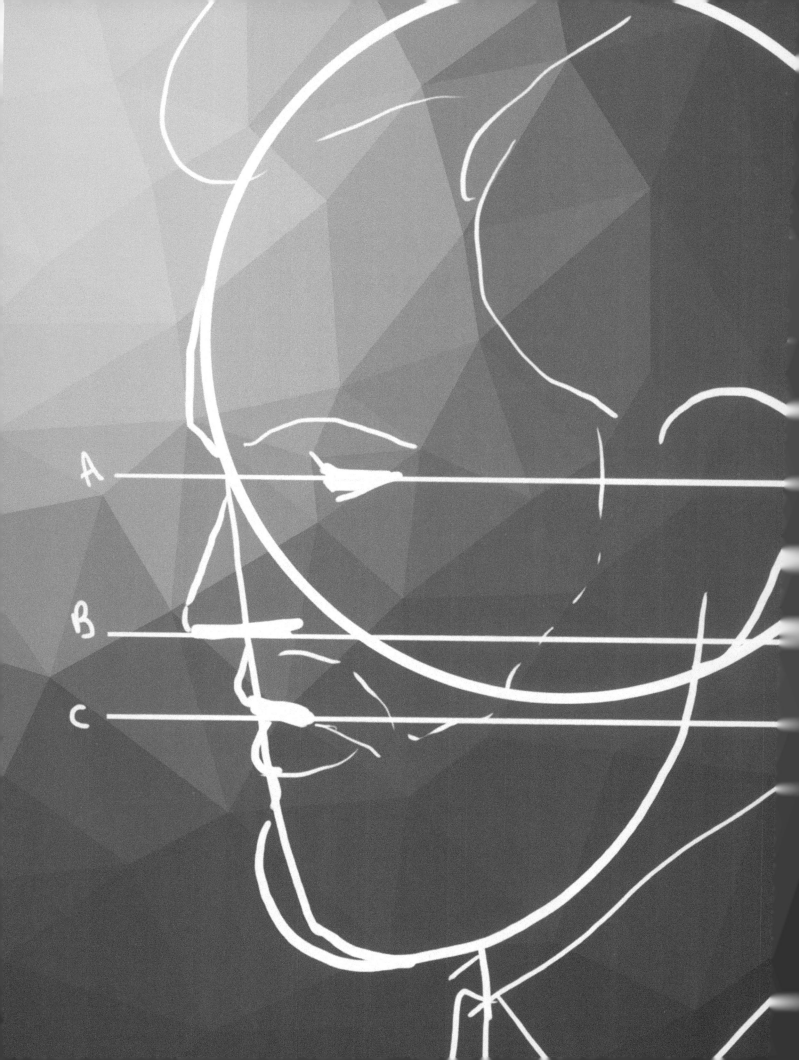

HOW TO USE THIS BOOK

The first part of this book looks at each facial feature (eyes, nose, and mouth) individually, so you can learn how to draw them one at a time. The second part combines the features and discusses details beyond the face, like hair, clothing and accessories, coloring, composition, and shading.

Each activity starts with a short lesson and step-by-step drawings to show you the process and help you learn by seeing examples. Think of these drawings as guided practice; you will have your own drawing style and shouldn't feel any pressure to make exact copies of my drawings.

I start with lessons you can draw along with, but in the final chapters, I want you to go out and draw from life. You might ask a friend or family member to pose for their portrait, and I tell you how to gather your own ideas and references for your art.

You don't have to follow the lessons in any particular order. For example, if you're having trouble drawing a specific part of the face, you can always flip to a different lesson. Remember, practice makes perfect; repeating activities can help you improve your skills.

And feel free to try out your own ideas. Most of all, have fun!

TOOLS

You only need basic tools and materials for the lessons in the first half of this book. They are affordable and easily available. In later chapters, some activities include materials for color and shading, but there's no need to run out and buy a bunch of stuff—I sure didn't. Just use what you have on hand or what you're comfortable with.

Essentials

- Erasers
- Pencils (any type is fine)
- Sketchpad or sketchbook (labeled "mixed media").
 A good size is 8.5 by 11 inches.

Nice to Have

- Acrylic paint (if you wish to paint in chapter 11)
- Colored pencils: Prismacolor pencils are great
- Colored markers
- Ink pens or markers, such as Micron or Sharpie (fine point)
- Pastels: chalk or oil
- Watercolor palette and brushes: You don't need lots of different colors, because you can make them all with the primary colors—red, yellow, and blue.

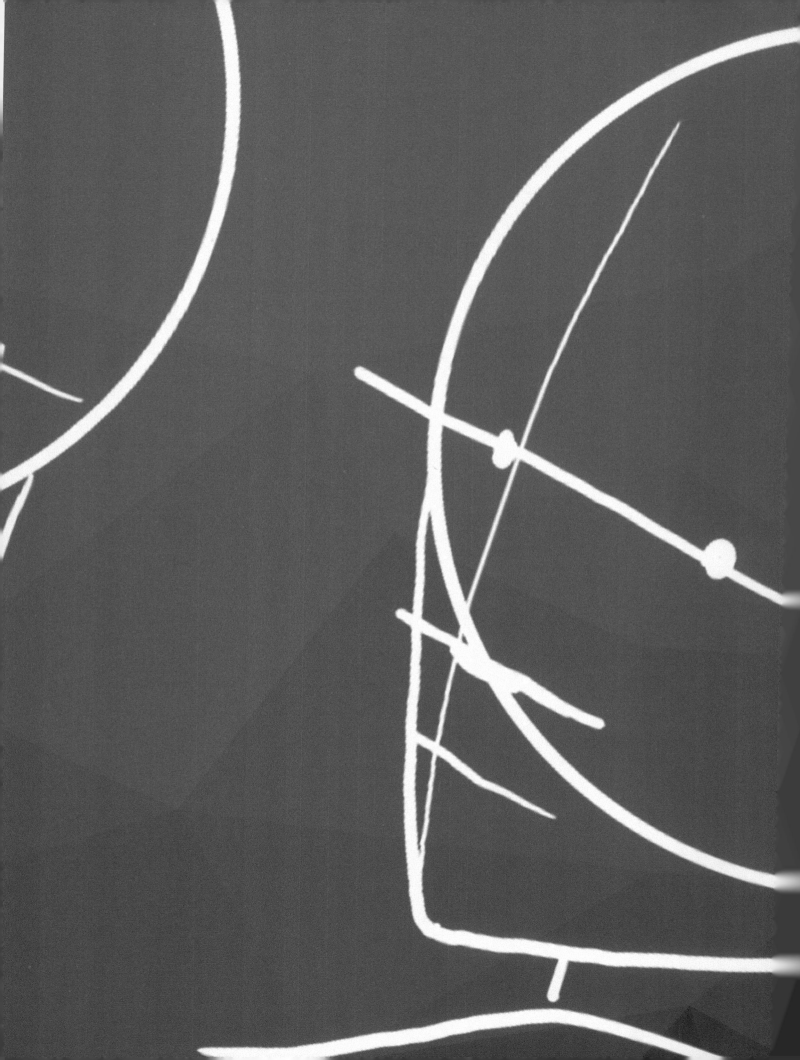

Part One
THE BASICS

Framing the Face

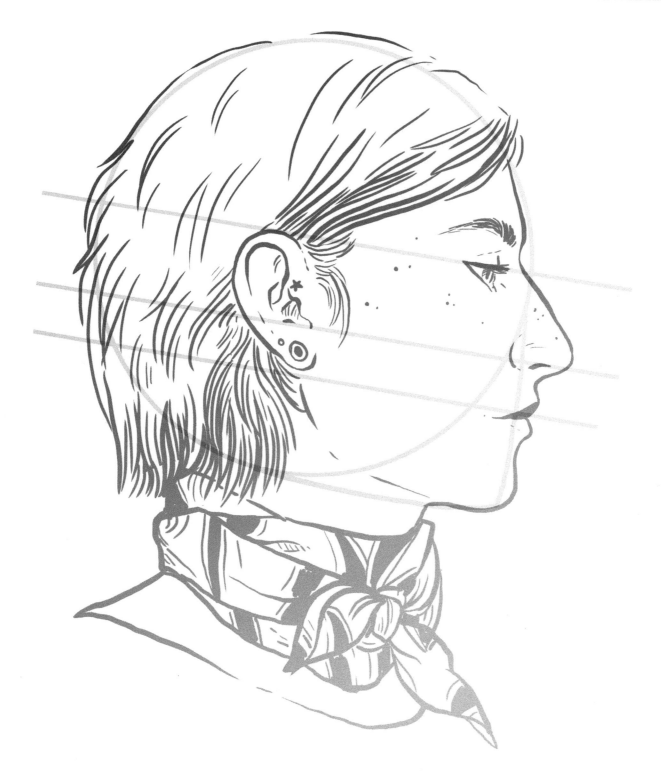

Heads can be round, oval, square, long, or short. Their features (eyes, nose, and mouth) can be just as varied.

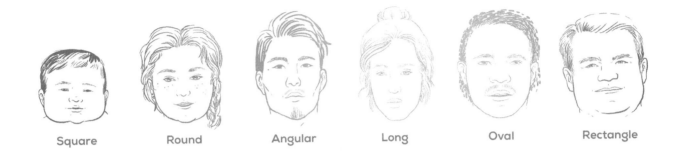

Square Round Angular Long Oval Rectangle

First, I draw a circle for the skull. Then I add a triangle for the lower jaw. Near the center of the circle, I draw three horizontal lines (*A, B,* and *C*). *A* has the pupils of the eyes, *B* the nose, and *C* the lips. The ears lie between *A* and *C*. These lines can be equally spaced, or you can change their **proportion** to create different personalities. Then I make a vertical line (*D*), which divides the face from the forehead through the nose to the chin.

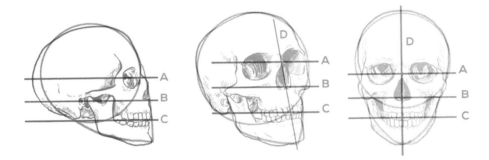

You can also tilt the sketch to show the face at different angles. So, although portraits may seem hard at first, it really comes down to drawing three lines and placing a few shapes on those lines.

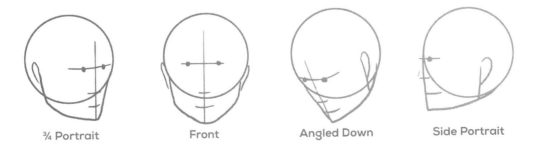

¾ Portrait Front Angled Down Side Portrait

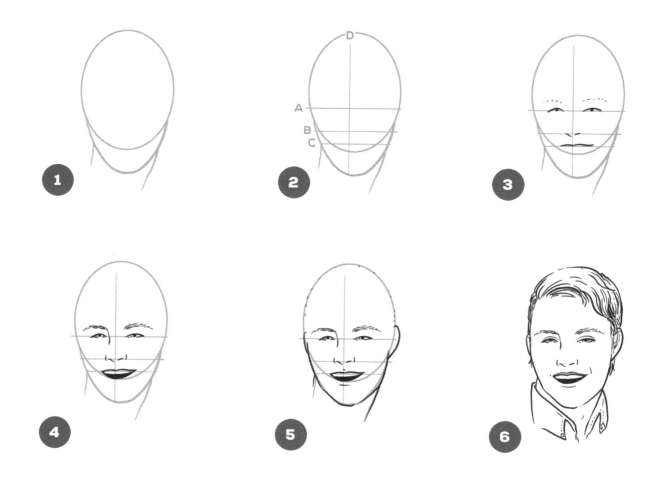

1. This subject has a long, narrow face, so lightly pencil an oval shape. Add a curvy triangle for the jaw and chin and a hint of neck.

2. Now add the *ABCD* lines. Let's give your subject a long nose and a big smile.

3. With a marker or darker pencil, draw the upper lip on line *C*, the nostrils on line *B*, and the pupils on line *A*. Draw the upper eyelids above line *A* and add a few dots where the eyebrows will be.

4. Define the eyes, nose, and mouth.

5. Now draw the face shape. Angle the lines to make the chin. For the hair, draw dashes to show how high it'll go. Draw the ears between lines *A* and *C*.

6. Add final details such as hair, lips, eyelids, and anything more.

Now that we've tried one together, practice a few on your own. Remember, your figures don't need to be perfect. Have fun!

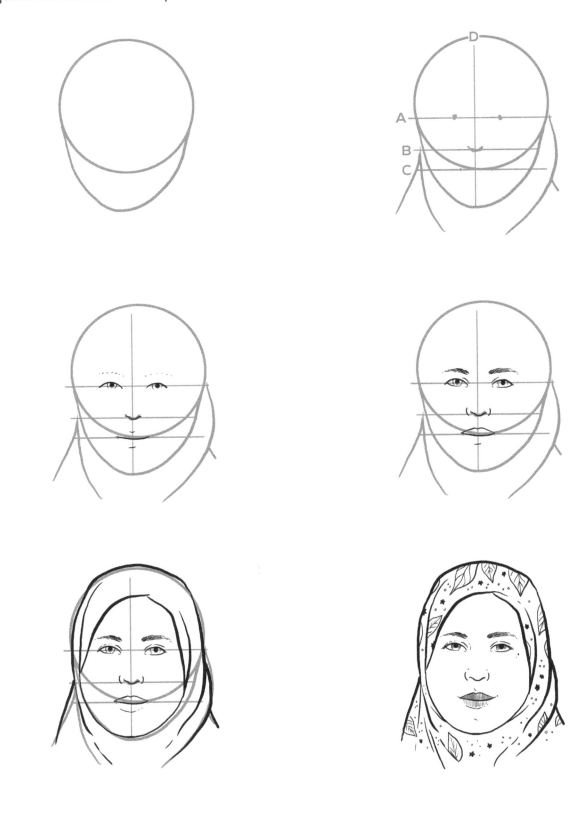

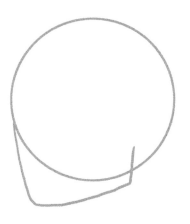

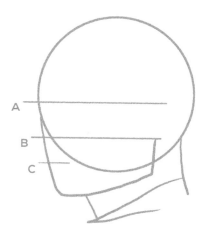

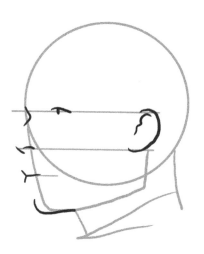

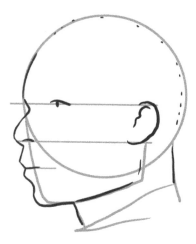

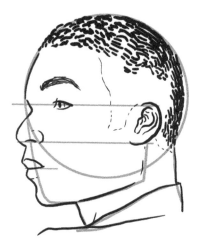

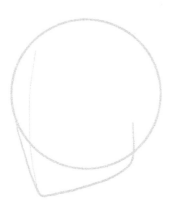

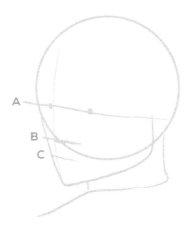

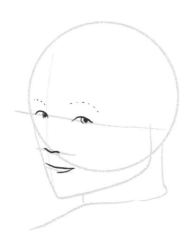

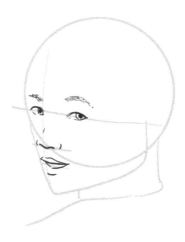

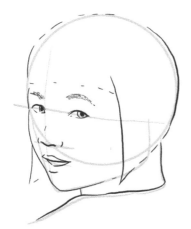

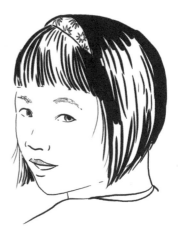

Eyes and Eyebrows

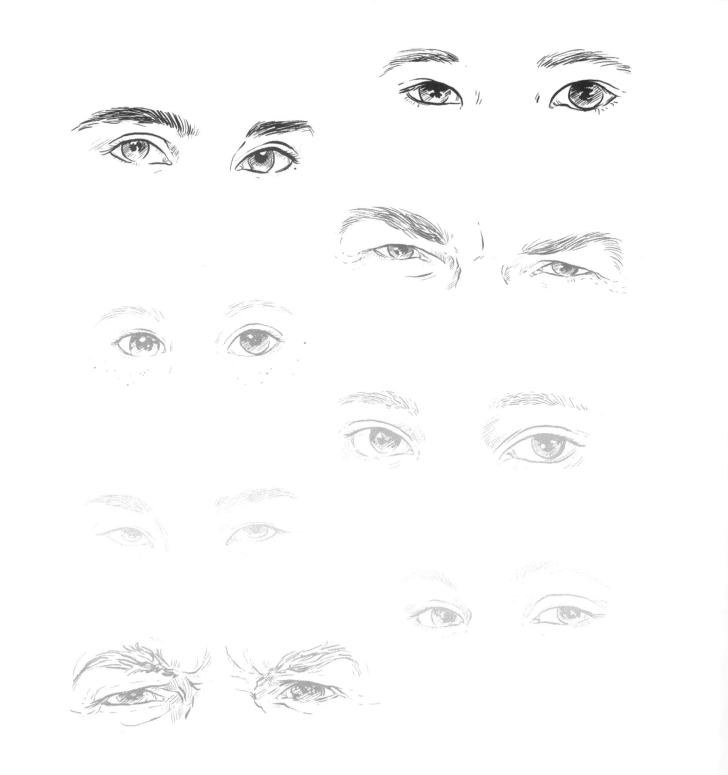

Eyes sit deeper in the face and capture more shadows than eyelids, which attract more light. The upper lid line is thick because of the eyelashes, but you don't have to draw every lash—a few curling around the edge of the eye is enough.

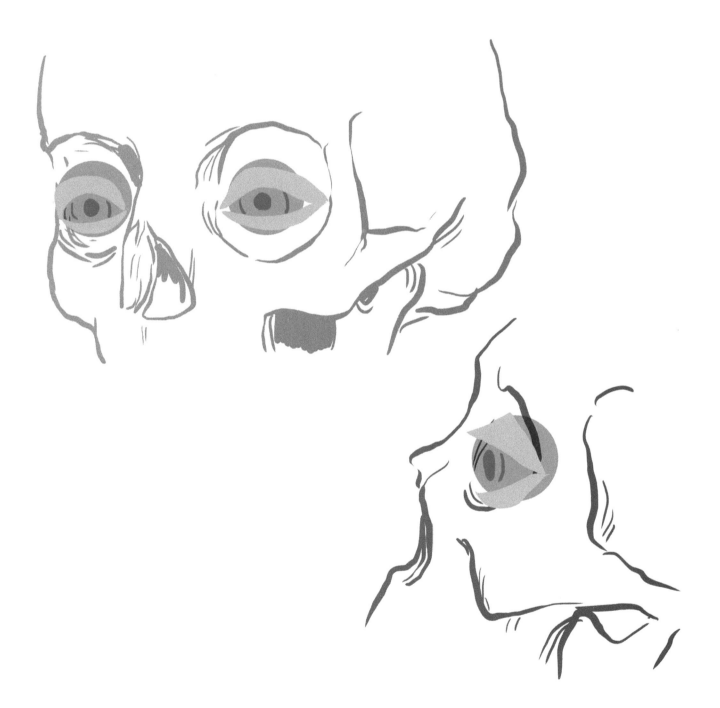

Eyeballs are reflective, so I use a black scribble for the pupil. I also shade the iris, making it darker around the upper lid, which adds **depth**. Unless the eyes are wide open, the top and bottom of the iris circle are usually cut off by the eyelids.

FRONT

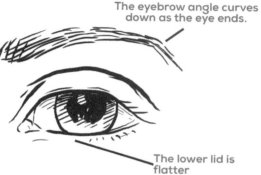

The eyebrow angle curves down as the eye ends.

The upper lid is more open and curved.

The lower lid is flatter

¾ VIEW

The eye closest to you is larger, and its shape is more almond.

The eye that's further into the head turn is distorted. It appears as more round in shape.

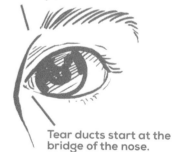

Tear ducts start at the bridge of the nose.

SIDE

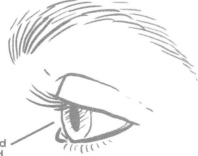

The iris is round, the lid makes a ❯ shape, and the lower lid is more curved.

Eyebrows start above the inner corner of the eye, then arch into a curve that peaks around the outer eye area. They then slope downward and usually end just past the length of the eye. I draw the hairs with some vertical lines in the center that slant toward the side of the head. A few randomly angled lines make brows look more natural.

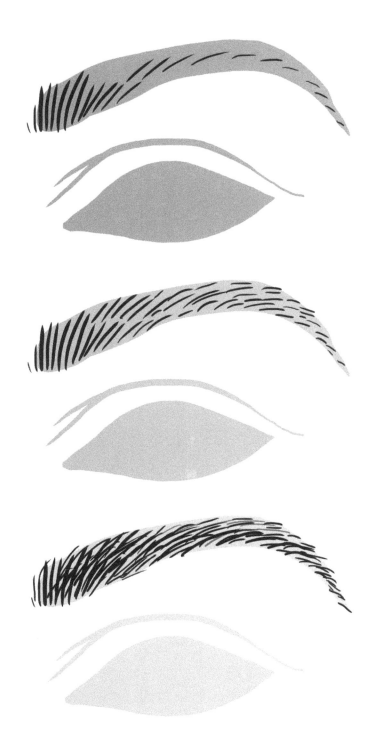

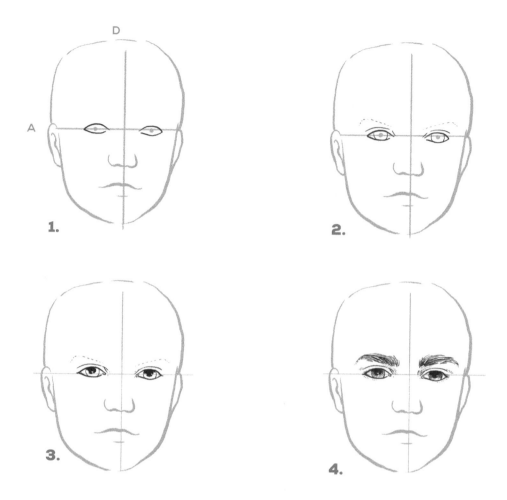

1. 2.

3. 4.

1 Lightly sketch a basic head with a line for the mouth and a U shape for the nose. Draw the *D* line, then the *A* line. Draw an almond eye shape using a darker pencil. (Quick tip: The space between the eyes is usually the size of one eye.)

2 Draw the upper eyelid, following the shape of the eye. Then draw the iris. Dot where the eyebrows will go.

3 Add details. Draw a small, thin curve for the rim of the eyelids. The tear duct is oval. The upper eyelid isn't always a perfect curve, so add another fold of skin. Draw the pupil. Extend the upper corner line of the eyelid and make it thicker.

4 Using thin lines, shade the iris, dark to light, and some of the white of the eye (it's darker on the top of the eye). Add eyelashes and eyebrows. Shade a bit around the eye. Most shadows hit the area between the tear ducts and eyebrow and around the outside of the upper lid and side of the nose.

Now that we've tried one together, practice a few on your own. Remember, your figures don't need to be perfect. Have fun!

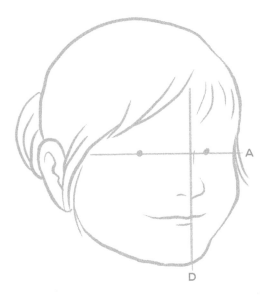

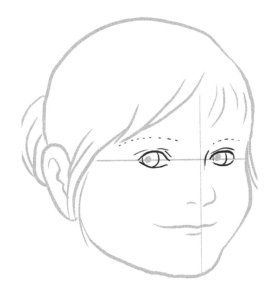

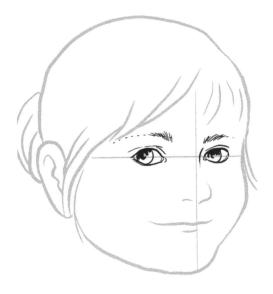

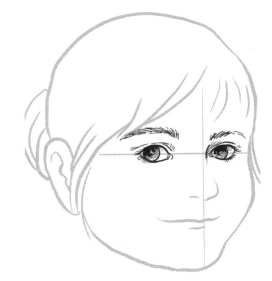

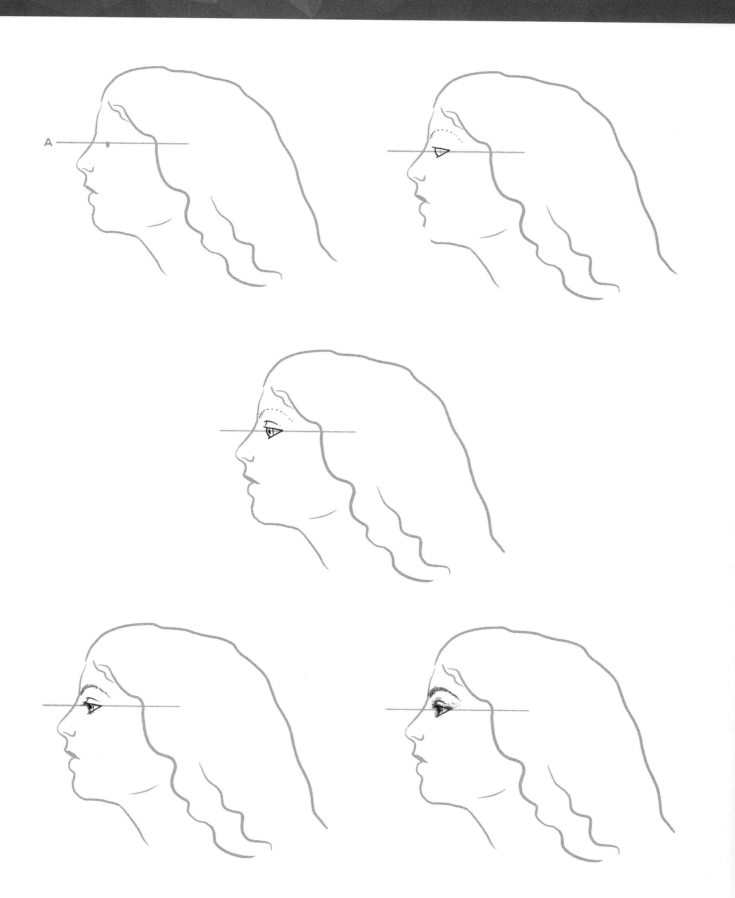

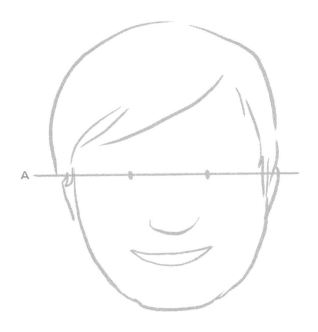

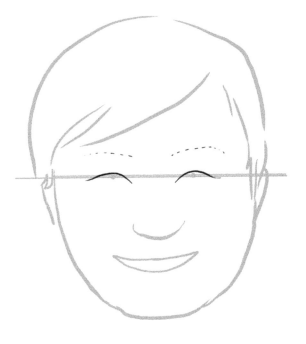

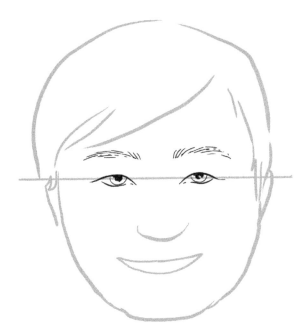

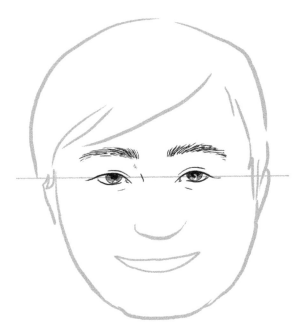

Nose and Mouth

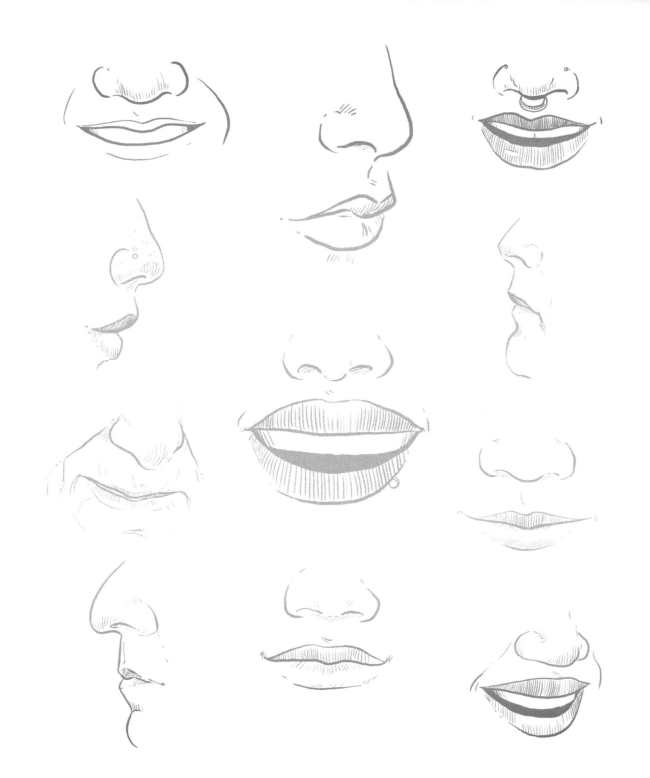

The nose rests on the *D* line, dividing the center of the face. The nostril sides are often in line with where the eyebrows begin, and the outer corners are in line with the tear ducts. The nose is like a cone, narrowest right under the eyebrows and widening into a ball shape near the lips.

A mouth's upper lip is often shaped like two hills close together, while the lower lip is like an orange slice. Light hits the lips differently, so the upper lip is darker. In a resting face, lip length is usually the same distance as from one eye pupil to the other.

Keep in mind that too many details around the mouth can make a person look older. Also, you don't have to draw every tooth; instead, focus on the contrast between tooth color and the darkness inside the mouth. Include any detail like a missing tooth or gap.

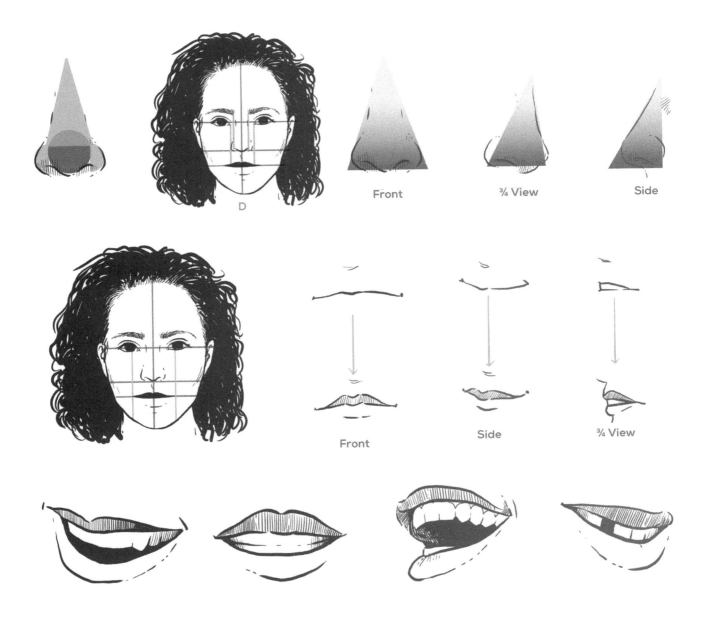

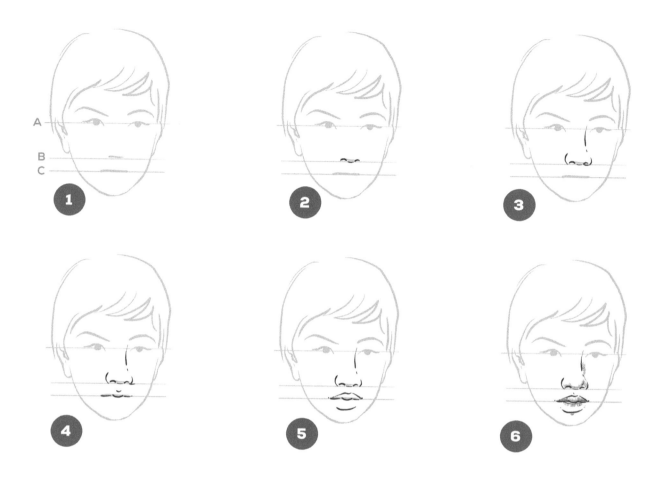

1 Draw a light sketch of a head with lines showing where the nose and mouth will be.

2 Draw the nostrils and nose tip.

3 Draw the bridge and side of the nose, making a broken line on the side of the face that will be in shadow. This line starts near the eyebrow and curves to the nostril.

4 On the C line, draw a line like a stretched-out M. Next, draw a little U shape in the center of the upper lip.

5 Use lines to connect the U to the corners of the mouth. For the lower lip, draw a simple, light stroke.

6 Often, less is more when drawing faces. Draw some delicate lines to show the curve of the nose and lips, and add shading to the dark side of the nose.

Now that we've tried one together, practice a few on your own. Remember, your figures don't need to be perfect. Have fun!

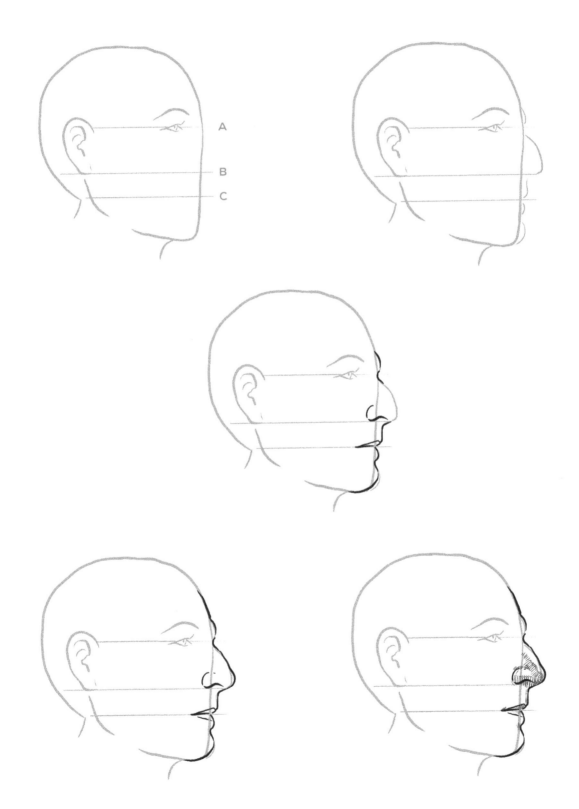

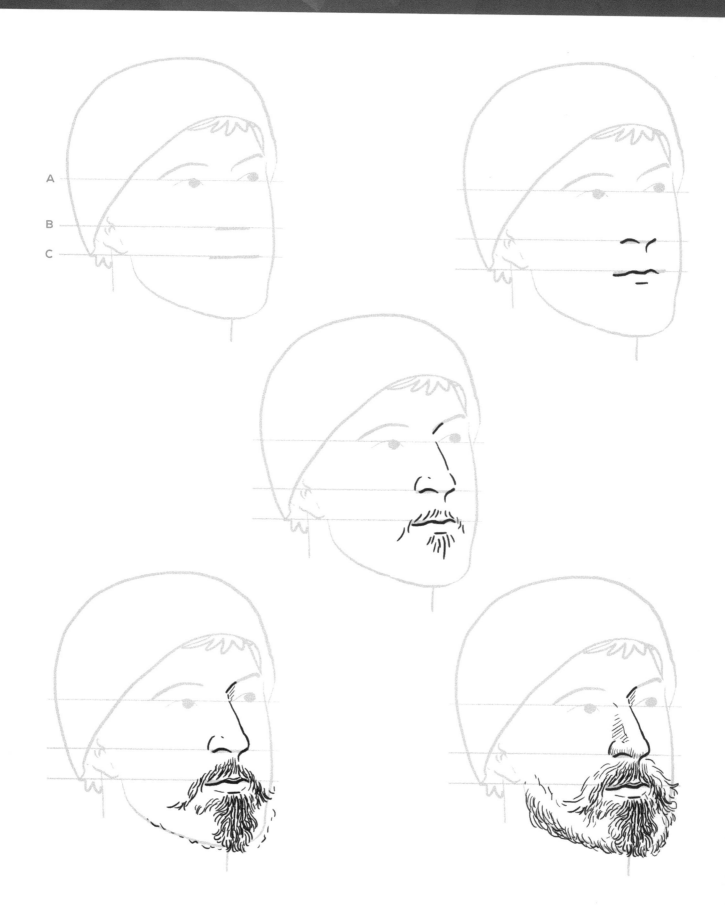

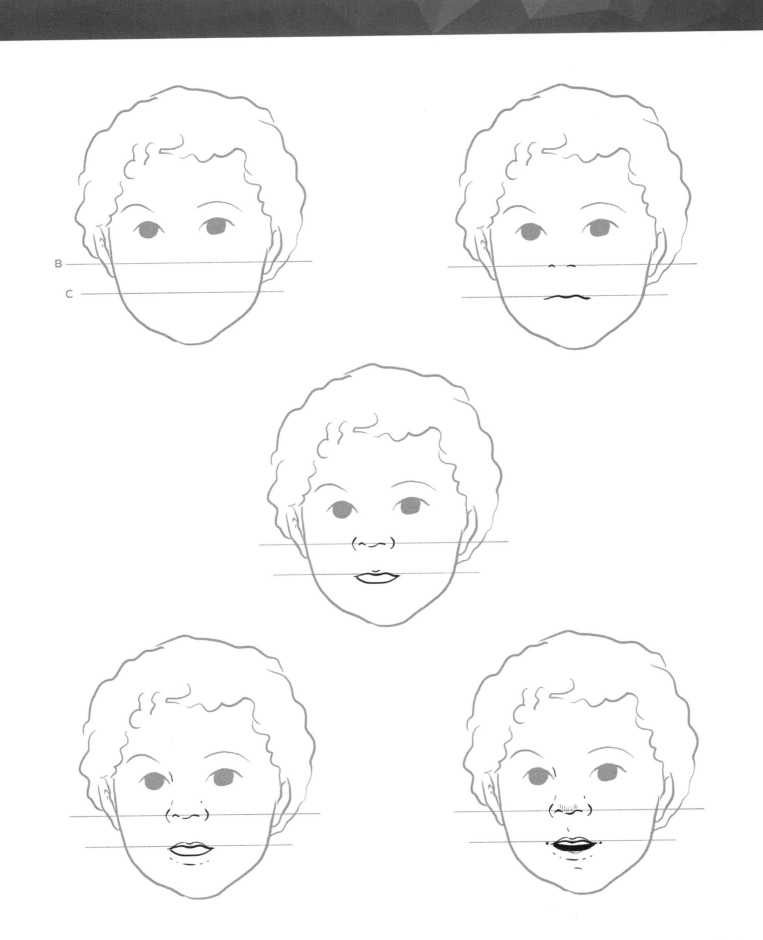

Expressions

The way to master drawing expressions is to understand that all facial features are connected by muscles. Grab a mirror and smile. Your mouth moves, but so do your cheeks. Squint, and your eyebrows will move and creases will show on your nose and brow.

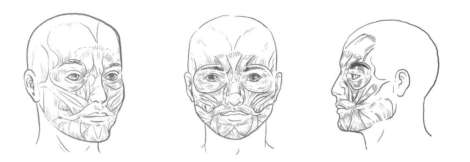

I slant and arch features depending on the expression. The more dramatic the slant, the more exaggerated the expression. To me, the eyebrows and mouth best express what someone is feeling.

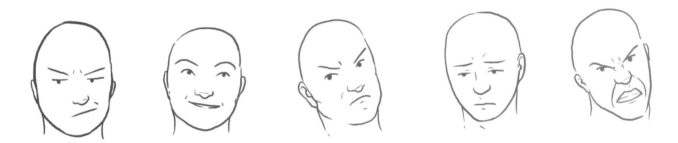

The shape and size of features also vary according to expression. A mad face might have tight, thin lips, but someone laughing will have a mouth wide open, showing teeth. Someone sad will have eyes squinted shut, wrinkling the skin around them, but someone surprised will show more white of the eye and arch their brows toward their hairline.

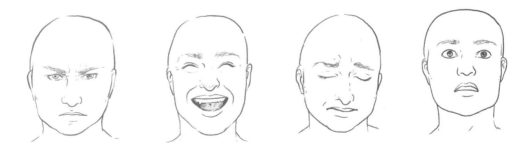

The easiest way to draw expressions is to use your own face as the model.

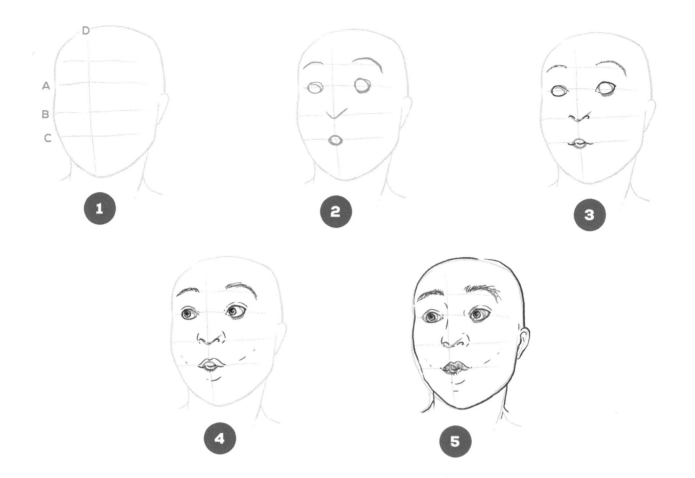

1 Let's draw a surprised face. First, lightly sketch a head with *ABCD* lines.

2 Draw the features. The eyes are round and fully open. The eyebrows are high. The mouth is pinched and slightly open, and the nostrils are slightly flared.

3 Define the features with a darker pencil. Draw the eyelids, dot where the eyebrows go, and draw the nostril holes and the start of the upper lip.

4 Finish the features. Because the eyes are so open, there is white above and below the iris. And since the mouth is stretched and slightly sucked in, the cheeks have hollows.

5 Define the chin, and add detail to the eyes, eyebrows, and bridge of the nose. Finally, draw the complete shape of the head.

Now that we've tried one together, practice a few on your own.
Remember, your portrait doesn't need to be perfect. Have fun!

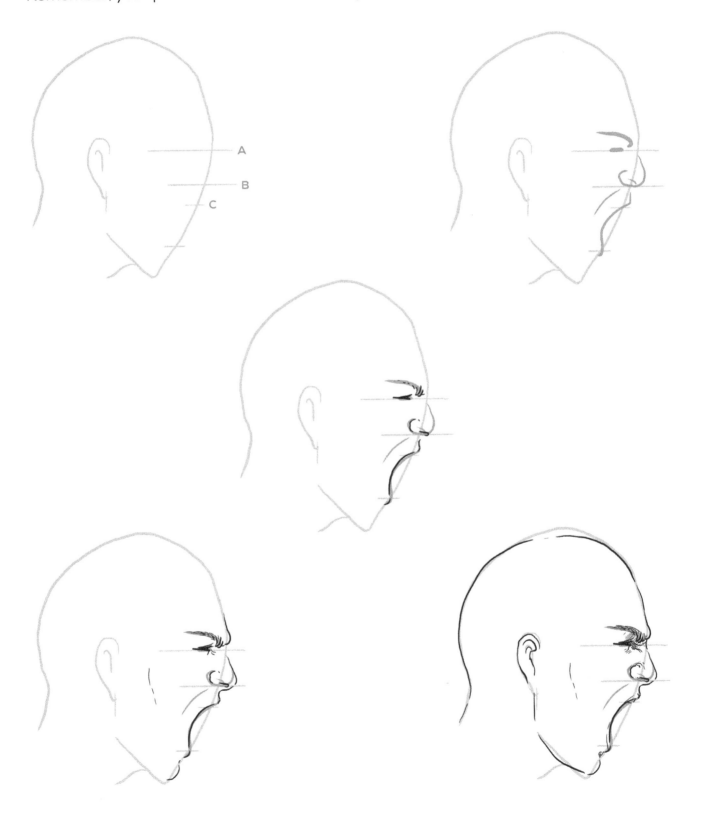

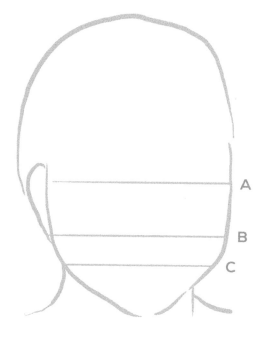

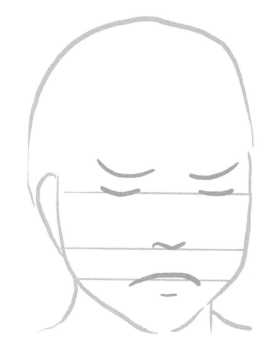

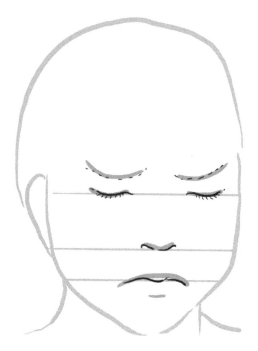

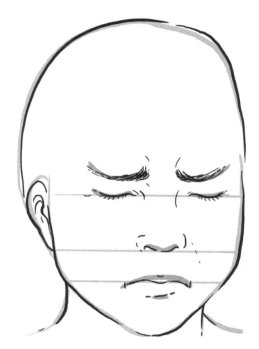

A

B

C

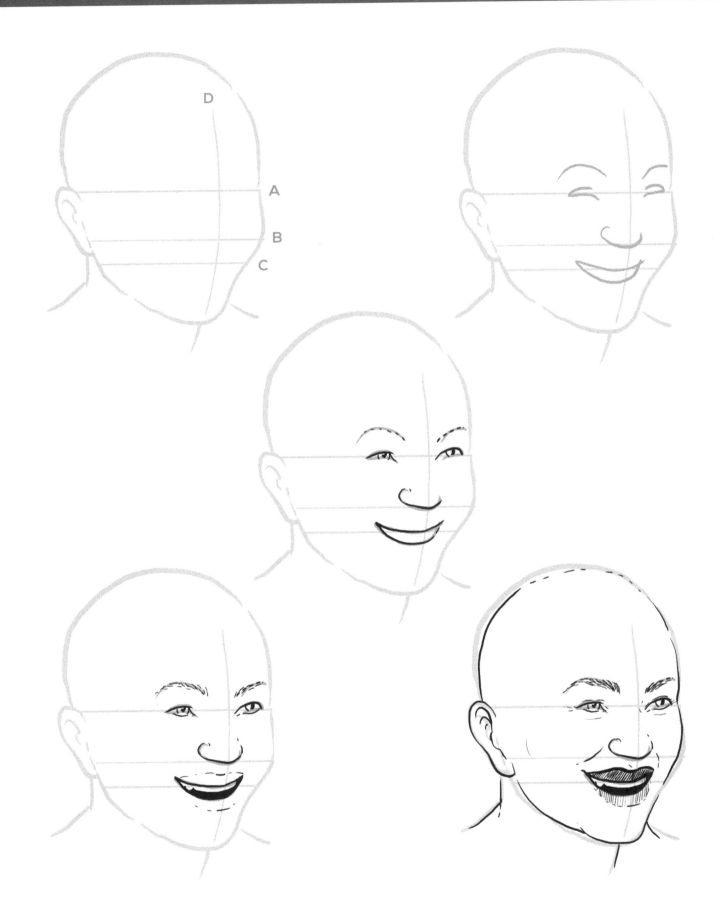

Part Two

THE DETAILS

Shading

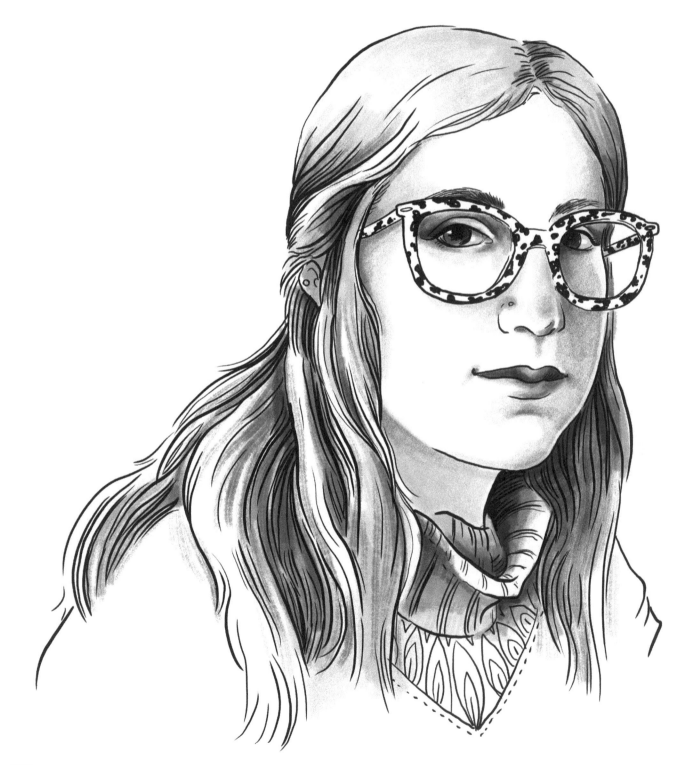

WORDS TO LEARN

highlights: the lightest tones, almost white; use very light pen pressure or use an eraser to get back to white

tone: the intensity and saturation (richness) of color

shadows: the darkest tones; use heavy pen pressure

midtones: the color values between light and dark; use medium pen pressure

Let's add **tone**. Think of areas of the face as slopes that pop outward or sink inward.

 The cheekbones, top of the nose, forehead, eyebrows, middle of the chin, and part of the upper lip stick out, so they catch light and have the most **highlights**. Other areas, like under the nose and lower lip and around the eyes, don't get as much light because they sink inward or have **shadows** cast on them from other features. Flat areas—near the hairline and around main features—get shaded with **midtones**.

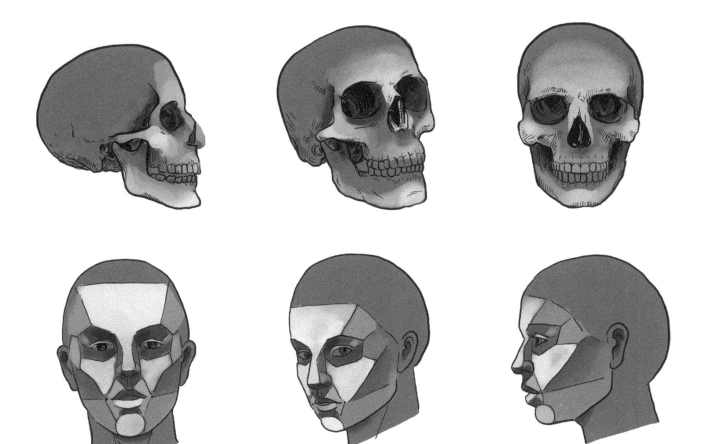

Pressing hard with a pencil produces a dark line, and pressing lightly produces a soft gray. You can use your finger to smudge shadows. When shading, don't change stroke direction; follow the direction of the skull slopes, such as the cheekbones curving in a \ / direction.

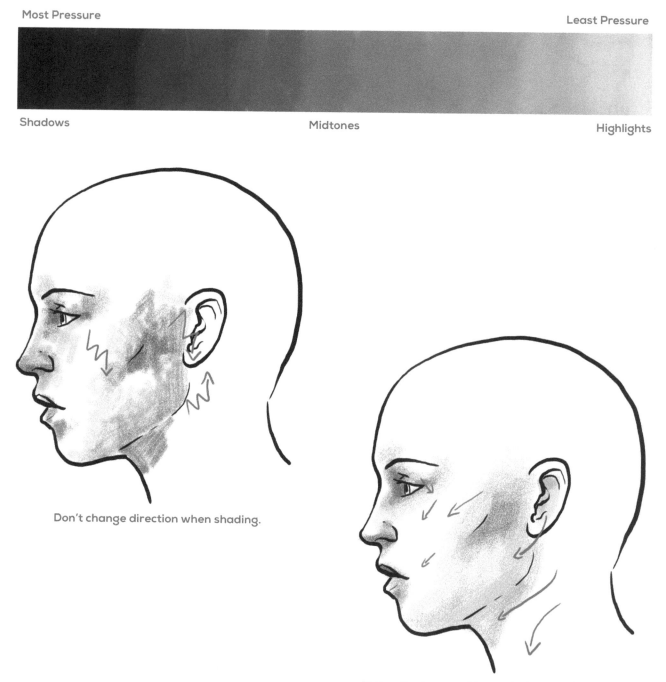

Most Pressure

Least Pressure

Shadows

Midtones

Highlights

Don't change direction when shading.

Follow the form and keep strokes consistent with direction and pressure.

Try lighting your subject strongly to see the contrast between light and dark. Lighting from one side makes a dramatic portrait. Lighting from the front means fewer shadows.

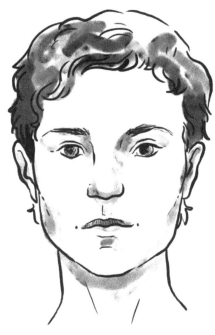

Directly Lit

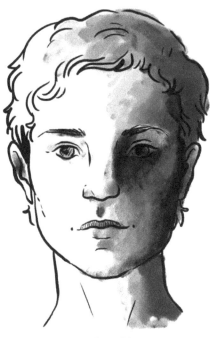

Side Lit

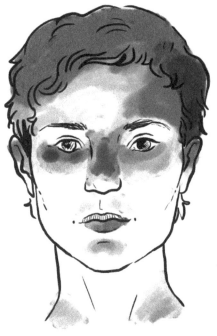

Lit from Below

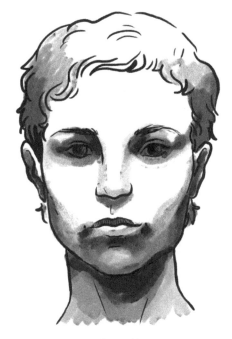

Lit from Above

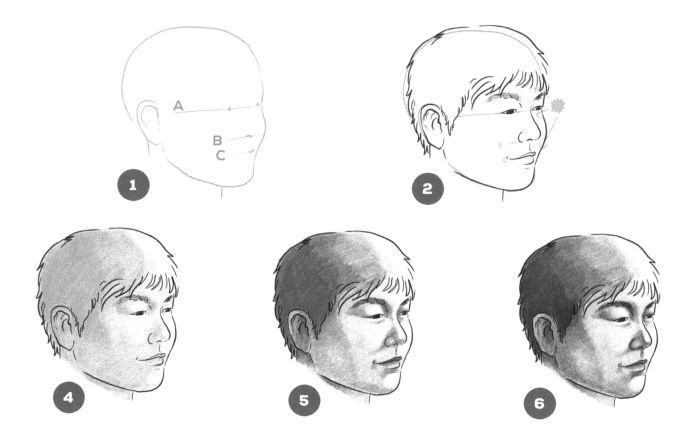

1 Lightly sketch a basic head shape with *ABC* lines.

2 Draw simple lines for the main features (eyes, nose, and lips). Here, the light is coming from the right, which means the left side will be mostly in shadow.

3 Lay down a broad, light shade where the shadow is cast: the side of the nose, left cheek, lips, eyes, and half of the chin.

4 Apply slightly more pressure with your pencil. Shade a bit darker under the cheek-bone and the chin, the side of the nose, and the eye area.

5 Keep building up shadows and blend them. Add highlights of pure white (with chalk or white ink, or by erasing) on areas that catch light the best—the eyes, tip of the nose, and lips. This really brings a portrait to life.

Tip: Always work from light to dark. You can build shadow, but it's hard to lighten areas without erasing. Also, don't go super dark when shading, because the drawing can look overdone.

Now that we've tried one together, practice a few on your own. Remember, your portraits don't need to be perfect. Have fun!

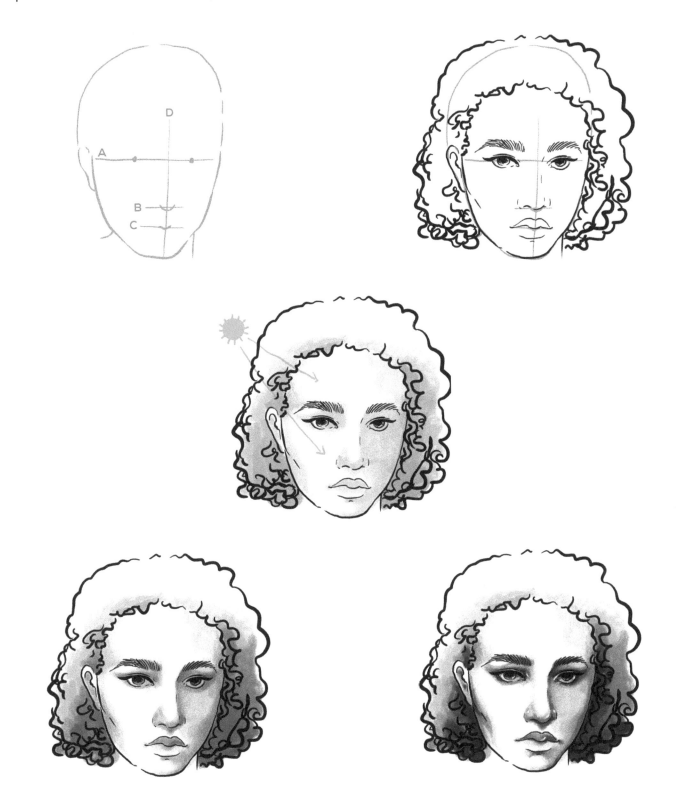

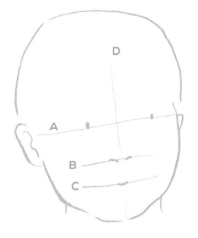

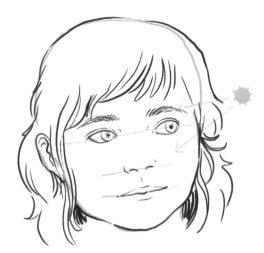

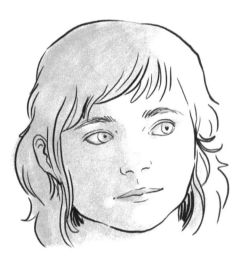

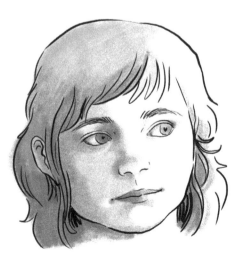

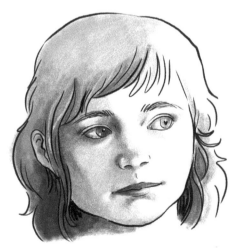

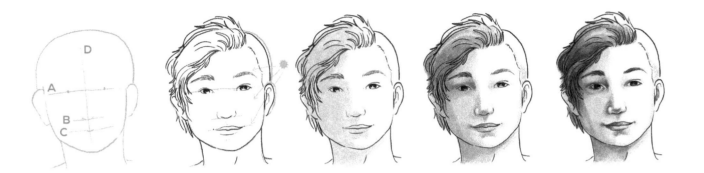

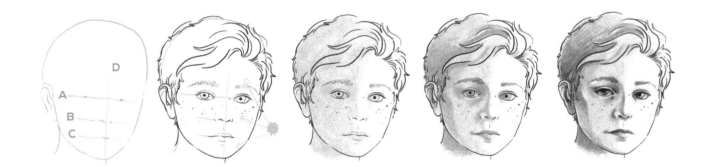

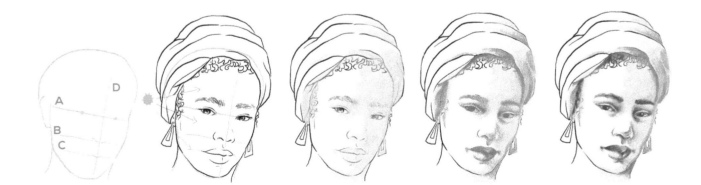

Beyond the Face

Now for the finishing touches: hair, beards, necks, and ears, plus any individual characteristics, like scars, freckles, moles, and glasses. These details bring out the uniqueness of your subject.

When sketching hair, think of how light travels across the shape of the head. Where are the highlights? Roughly draw hair with thick, broad, sweeping strokes, and shade in the direction the hair is curling. After that, add a few thin marks for wisps of hair around the face and head. Apply the same method for beards and mustaches.

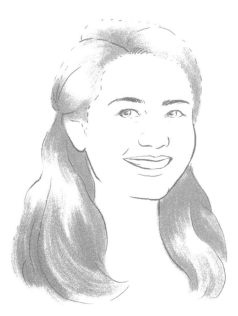
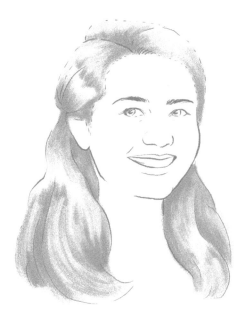
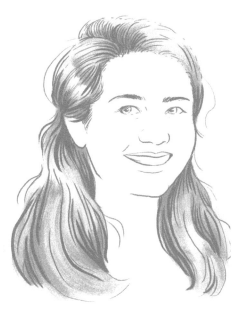

Ears come in many shapes and sizes and typically lie somewhere in between the eyebrow and mouth. Each ear is unique—they can have attached or free earlobes, be long or short, wide or narrow. They could have a variety of piercings, too!

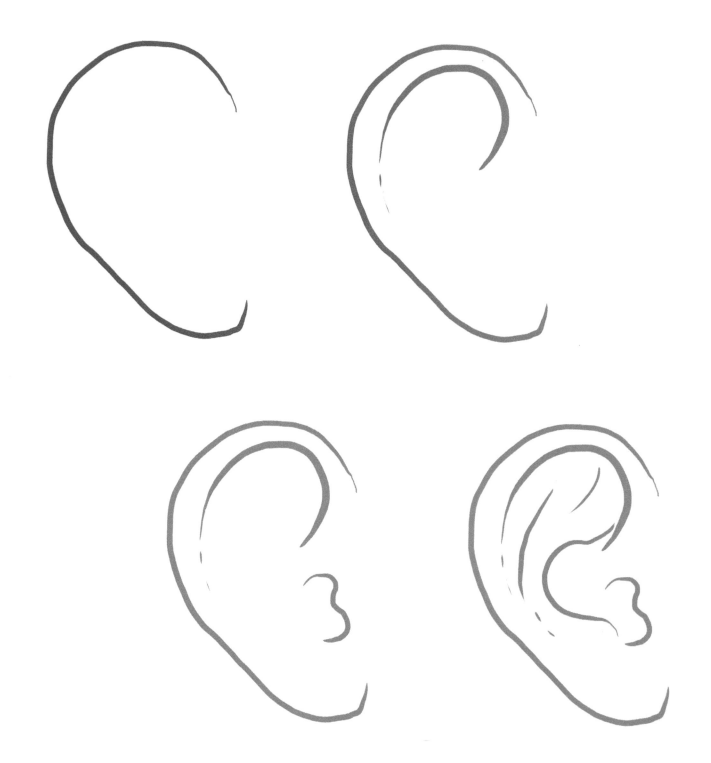

Necks connect to the head behind the earlobes. They come in different lengths
and thicknesses and can have features like Adam's apples and beards.

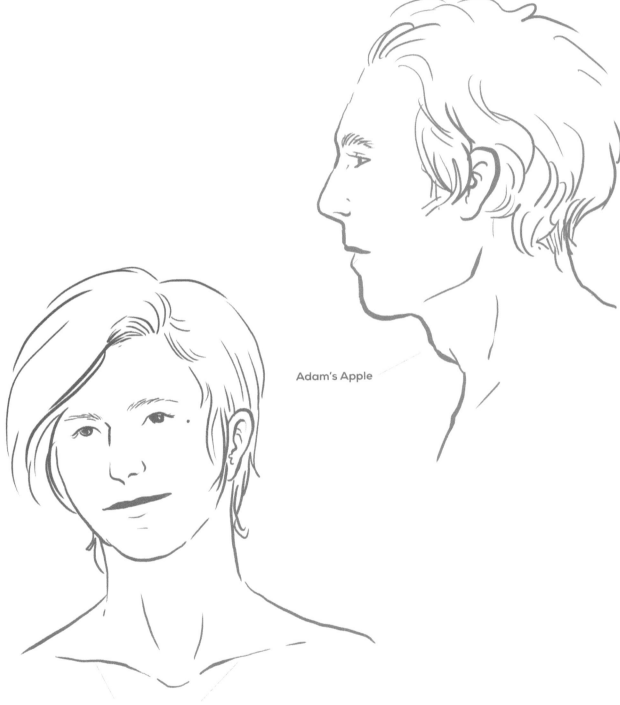

Adam's Apple

Clavicle (Collarbone)

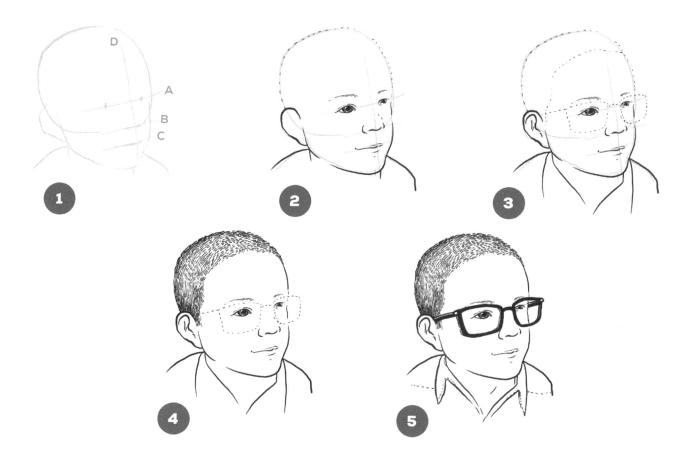

1 Lightly sketch a basic head with *ABCD* lines.

2 With a dark pencil, draw a simple portrait. Use dashes to show where the hair will go.

3 Start the ears between the eyes and lips. Draw a lopsided peanut shape, then draw the curve of the top of the ear and sideways C and M shapes. Start the shirt collar with a V shape. Sketch the glasses with dashed lines. Dash the hairline across the forehead.

4 For the hair, begin with short, dashes around the ears and the side of the head. Space them out more as you reach the top of the head, which is catching light.

5 Connect the dashed lines to form the glasses, then gradually thicken the line to make solid black frames. Frames often have the eyes at the center of the lenses, and they can cut off some of the eyebrows. Draw the outer ear and earlobes, then finish the shirt and add details, like his Adam's apple.

Now that we've tried one together, practice a few on your own.
Remember, it doesn't need to be perfect. Have fun!

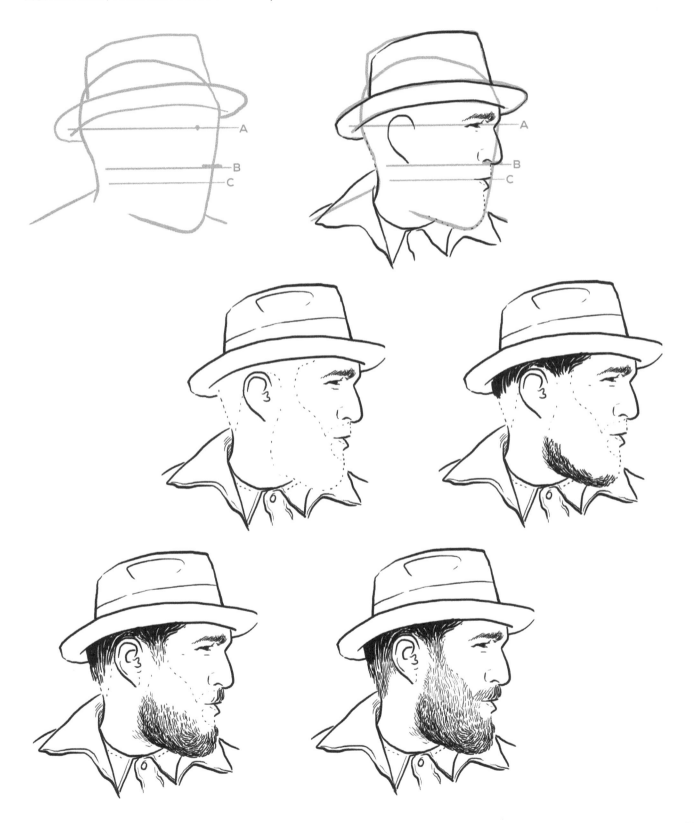

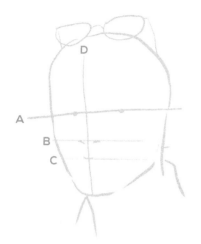

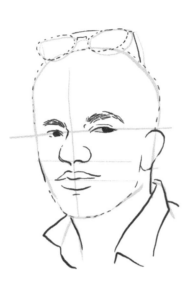

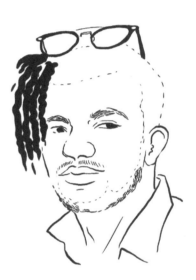

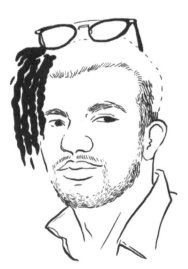

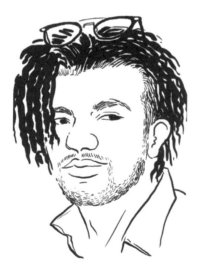

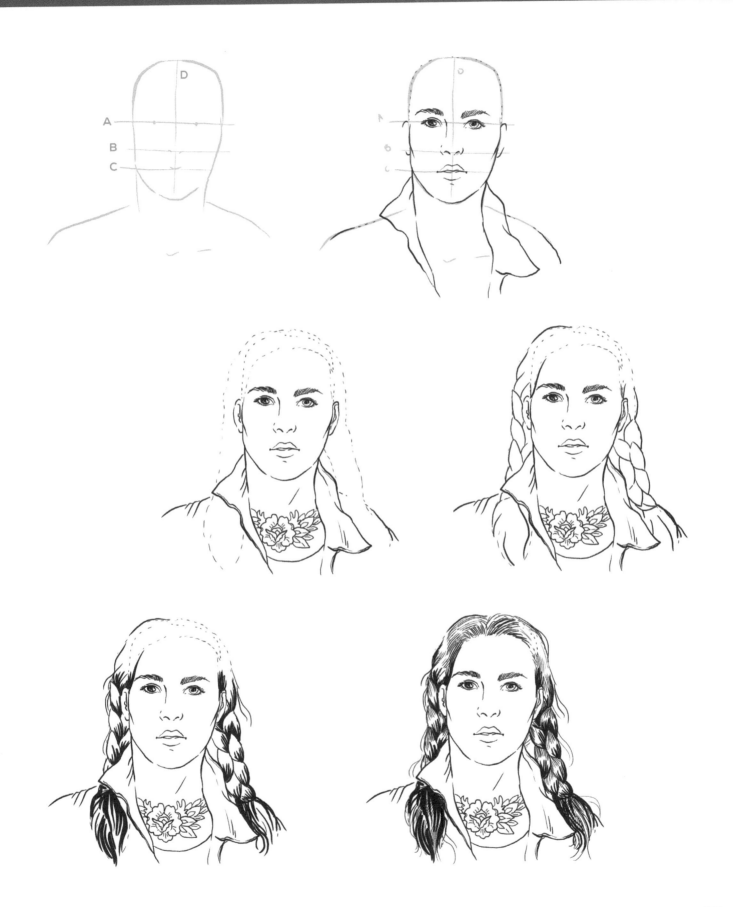

Your Selfie

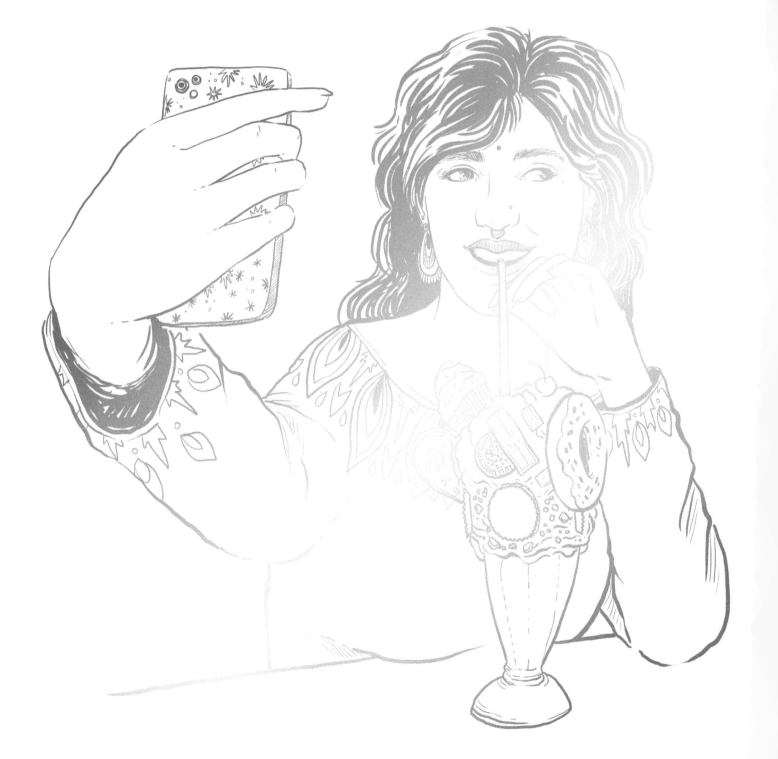

Now it's time to take a selfie!

The best light to use is daylight. Avoid **overexposing** your face; try standing at an angle so that some light passes across your face. If it's night, use a warm white lightbulb, or for fun, use Christmas lights! Using the flash overexposes things.

Stretch your arm out and keep it at the same height as your face. Taking pictures when you're holding your camera up high can make your portrait look distorted. You can also try resting your device on a shelf and using its timer. This is great for action shots and group shots.

Try taking many selfies: Make different expressions, tilt your head in different ways, or move your arm around to capture different angles.

The most important thing? Relax and have fun. Try out crazy hats or put on fun makeup—treat this as your own mini photo shoot.

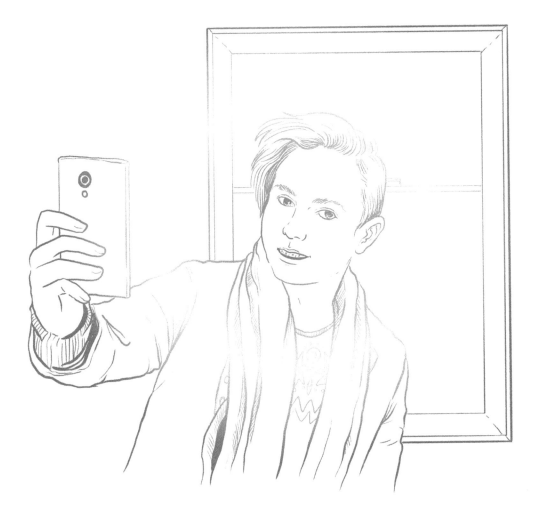

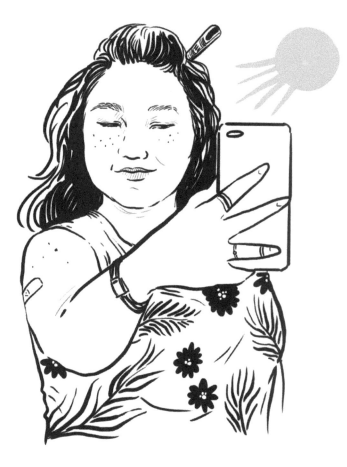

1. First, take a selfie! Be outside or near a light source to cast some shadow.

2. Print your selfie or look at it on your device for reference. Start with a light pencil head sketch with *ABCD* lines.

3. With a darker pencil or pen, sketch your eyes, nose, and lips. Draw a bit of your chin, neck, and shoulders, and dot where your hairline is.

4. Next, finish your facial features.

5. Draw some broad strokes for your hair, following the direction it flows.

6. Using your pencil, add some shadow with light-to-medium pressure.

Tip: If the shadow is too light to see, you can use your device to edit it to increase the shadow, decrease the highlights, and pump up the contrast. You can also desaturate (lessen the intensity) or remove color with an app to make the photo black-and-white and simplify it.

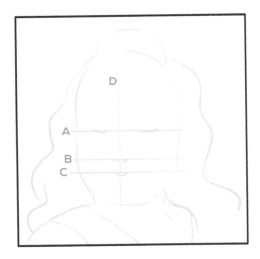

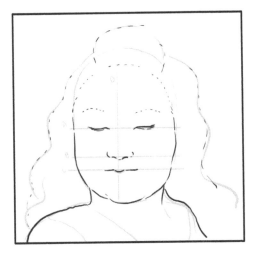

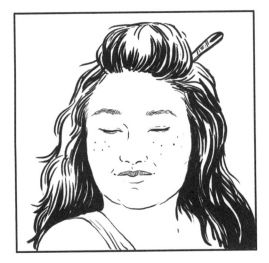

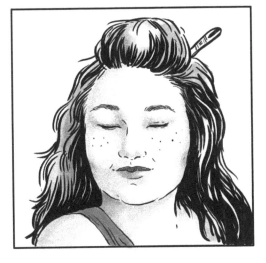

Now that we've tried one together, practice a few on your own. Remember, it doesn't need to be perfect. Have fun!

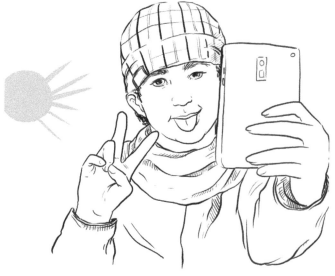

Strike a Pose!

Grab a Friend!

Your Subject

Find a comfortable, well-lit place for your subject to sit, like a window with natural light. Don't ask them to do something tiring like holding an expression. They can listen to music, watch TV, or play with their phone; just ask them not to move their head too much.

Place paper on an easel or a table on your left, and position your model on your right. This way, you can glance back and forth rather than move your head up and down. Lightly sketch quick marks with as many details as you can, and try to get the overall face. Your lines don't have to be perfect. After 5 to 10 minutes, let your model take a break. If you get your sketch done before time runs out, start drawing darker lines and shadows to define the facial features.

A great place to find subjects is out in public. You can sketch people in restaurants, dog owners with their pets in a park, or kids eating lunch in the cafeteria.

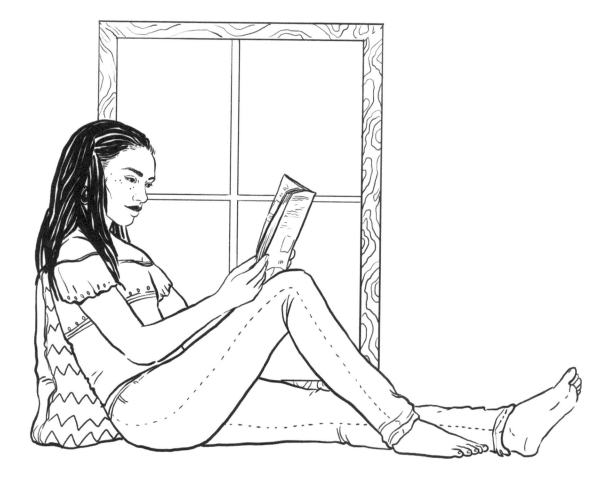

- Grab some face paint and paint your subject as a character, like a clown or superhero.

- Pose your model in front of patterned wallpaper for a beautiful backdrop.

- Dress your model to match your pet, then draw a portrait of the two of them in a scene.

- Use only shades of one color for a **monochromatic** drawing. Or use shades of only two colors for a **bichromatic** piece.

- Look to myths and legends for inspiration. Draw mermaids or centaurs using your subject as the portrait reference.

- Find a subject who also likes to draw and draw each other drawing each other!

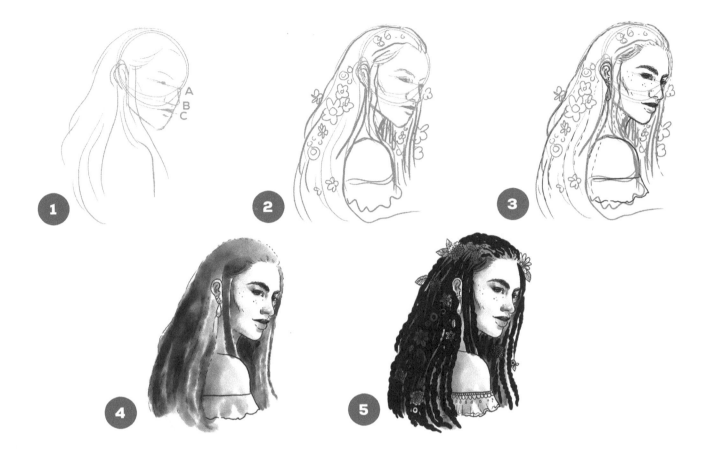

1 Set your timer and start with a light sketch of the basic head shape with *ABCD* lines.

2 Define the lips, nose, and eyes, and add movement to the hair. Because I'm making my model Rapunzel, I'm adding flowers, exaggerating her hair, and changing her outfit.

3 With a black pen, start drawing from the model. Focus on drawing everything you need from the model in front of you before your timer runs out.

4 Once finished, erase the sketch. Lightly draw where the shadows are. Give your model a short break and re-pose them after if you need to.

5 Once you're done with the model, finish the piece using your imagination. Detail all the flowers and her costume, and add the shadows with pencil.

Now that we've tried one together, practice a few on your own. Remember, it doesn't need to be perfect. Have fun!

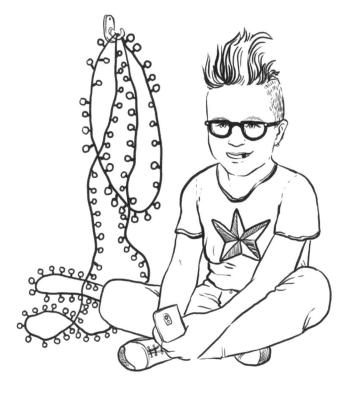

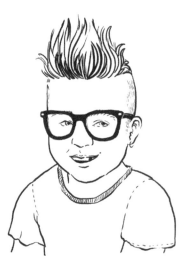

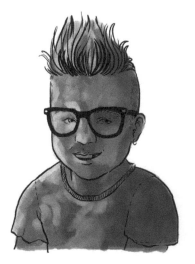

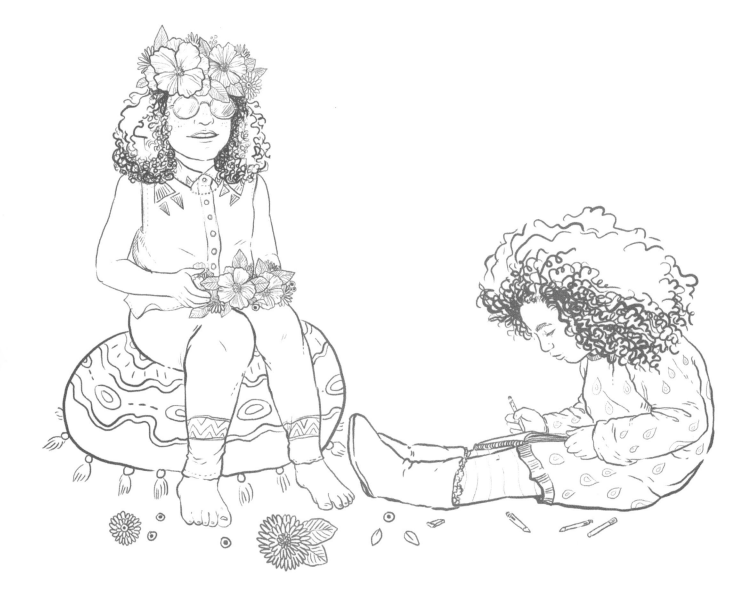

The Profile

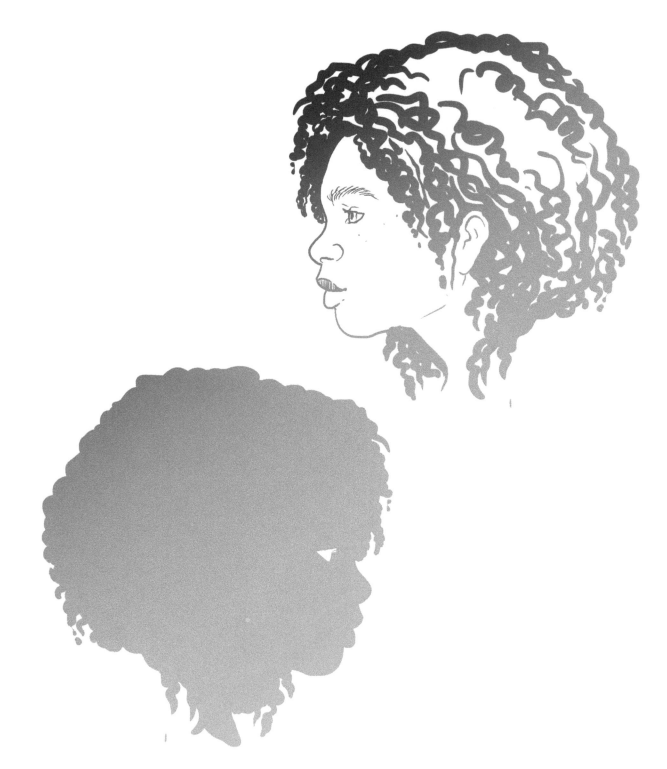

The side view of a person is a great way to see their defining features. Here are some common mistakes when drawing profiles:

- squishing the back of the head and forgetting there's a big brain back there

- forgetting that from the side, the eyes look more like **>** than a nut shape

- extending features too far out

- forgetting that lips and nostrils are three-dimensional and stick out from the face

Remember: Features don't lie flat. Your face indents (dips in) between your eyebrows and eyes, between your upper and lower lips, and between your lips and chin. It protrudes (sticks out) at your brows, nose, and lips.

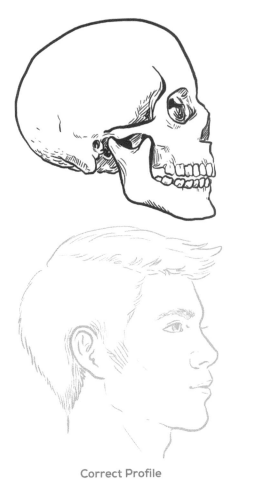

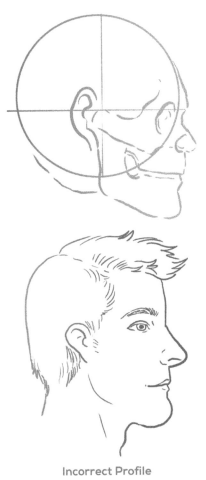

Correct Profile

Incorrect Profile

Before cameras, people who wanted affordable portraits of their loved ones made **silhouette** drawings. Once cameras were invented, this tradition died out, but recently it's had a comeback. You can take silhouette portraits a step further by using decorative paper instead of black or adding embellishments like rhinestones or gold leaf.

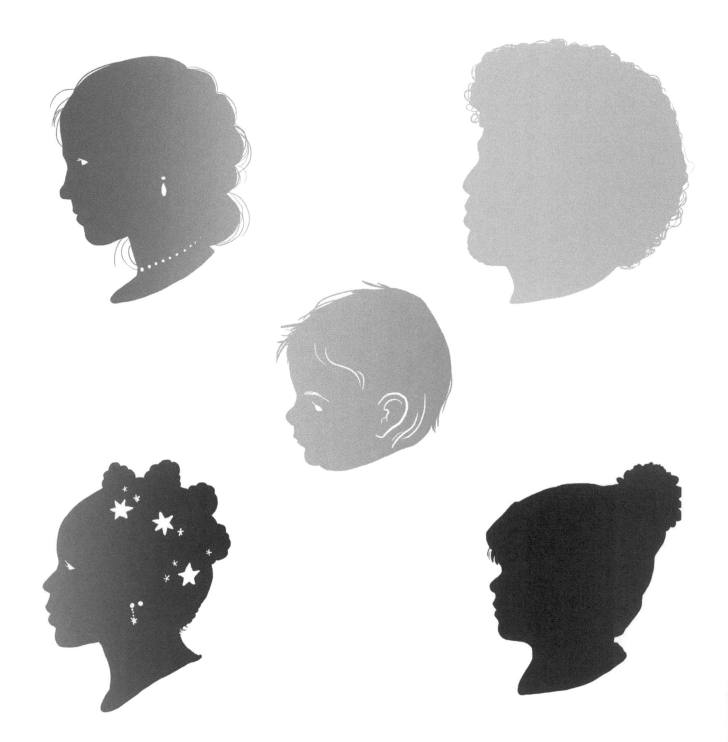

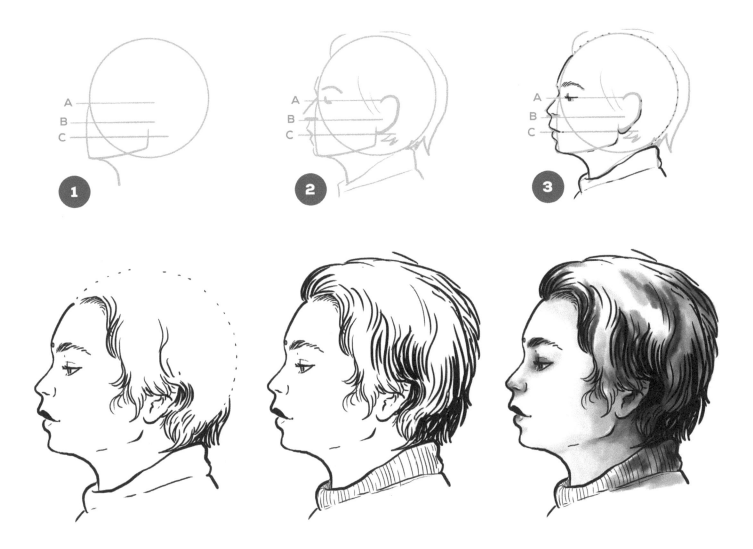

1 Pencil a circle for the skull, a curved triangle for the jaw, and *ABC* lines.

2 Sketch the indents and where the nose, lips, and brows reach out from the skull. Draw the ear and indicate the hairline.

3 With a dark marker, start your final line drawing on top of your sketch. Focus on just the face's outline. Then, start drawing some details.

4 Finish the face's details and start the hair. Using large strokes, show the direction of the hair and its darker areas.

5 Finish with some thin, fine lines for the hair. Then finish the outfit.

6 With pencil or watercolor (if your marker is waterproof), add shadow or color.

Now that we've tried one together, practice a few on your own. Remember, it doesn't need to be perfect. Have fun!

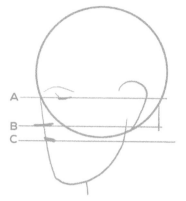

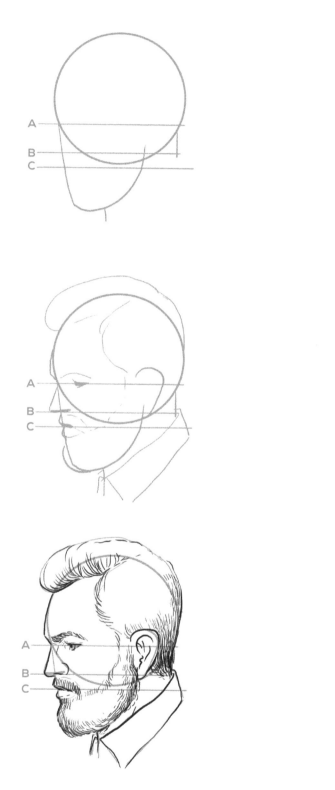

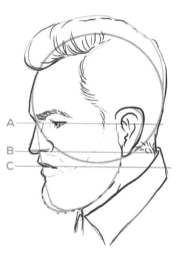

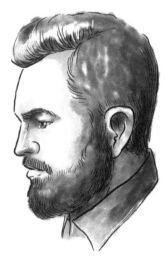

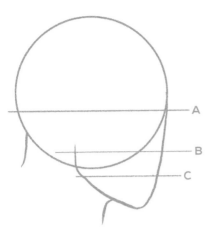

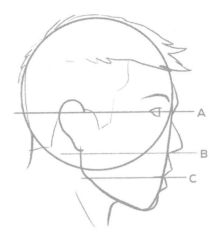

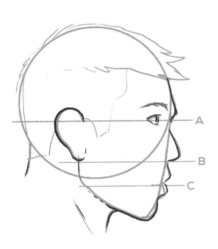

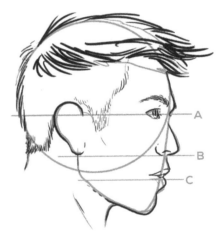

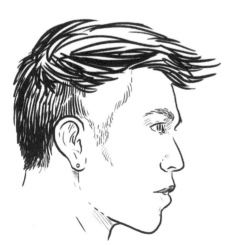

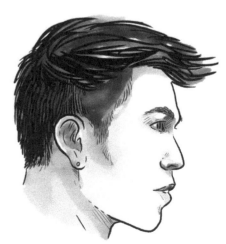

Portraits Through the Ages

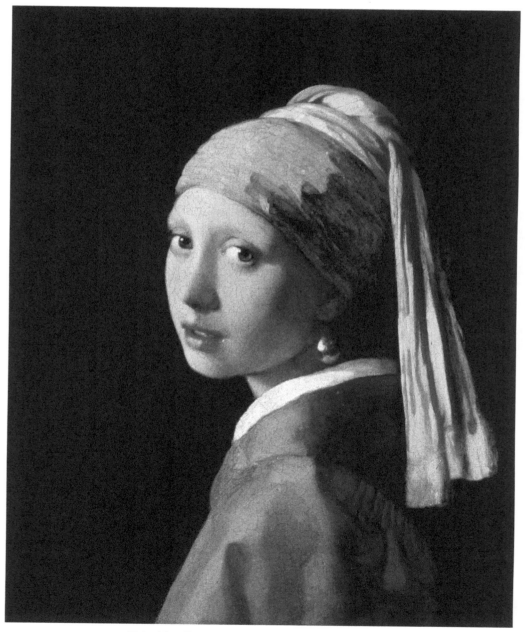

Girl with a Pearl Earring by Johannes Vermeer

WORDS TO LEARN

abstract: art that uses shapes, forms, colors, and textures to achieve an effect rather than to try to look super realistic

chiaroscuro: Italian for "light-dark," this technique is used to create dimension and drama with a sharp contrast in lighting

Portrait paintings through the ages have had a huge range of media and styles. In the ancient world, artists created portraits on papyrus scrolls in Egypt, pottery in Greece and Rome, and block prints and ink paintings in Japan and China.

Stela of Saiah

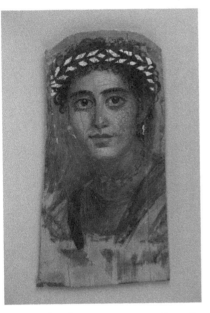

Portrait of a young woman in red

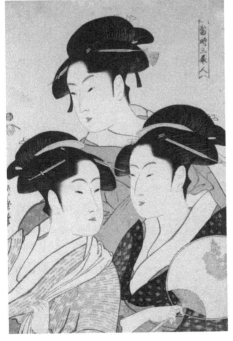

Three Beauties of the Present Day by
Kitagawa Utamaro

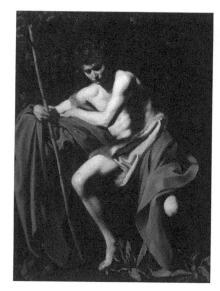

John the Baptist (John in the Wilderness) by Caravaggio

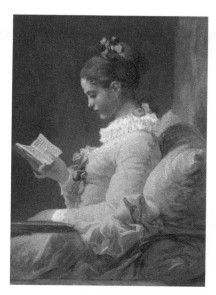

The Reader by Jean-Honore Fragonard

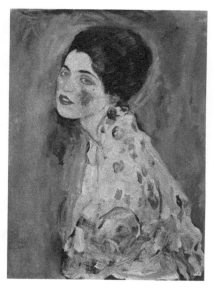

Portrait of a Lady by Gustav Klimt

1400 to 1600: **Italian Renaissance.** Artists like Leonardo da Vinci and Caravaggio used **chiaroscuro** to make almost photo-realistic portraits done in oil and egg tempera.

1700s: **Rococo.** During this period, there were lighter, airier paintings full of color, high fashion, and rough brushstrokes, like in Jean-Honoré Fragonard's *The Reader*.

Late 1800s to early 1900s: **Art Nouveau.** During this period, the style shifted to more graphic and decorative work like those done by artists Gustav Klimt and Alphonse Mucha.

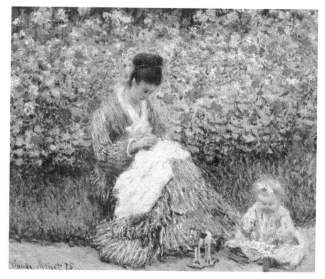

Camille Monet and a Child in the Artist's Garden in Argenteuil by Claude Monet

Late 1800s to early 1900s: **Impressionism.** Artists tried to capture an impression rather than an exact copy during this time. Famous painters from this period include Vincent van Gogh and Claude Monet.

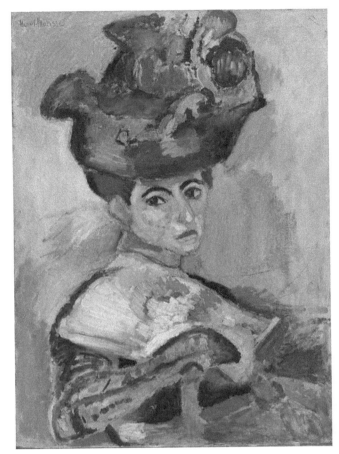

Woman with a Hat by Henri Matisse

Early 1900s: **Fauvism**. This period was similar in style to Impressionism but was rougher and wilder with vivid colors, as in the work of Henri Matisse.

1900 to the 1950s: **Expressionism**. Twisted forms and strong colors used to recreate emotions were the focus of this period. **Cubism** centered on creating flat, two-dimensional paintings using geometric shapes, like in the work of Pablo Picasso. **Surrealism** had strange, thought-provoking pieces taken from the subconscious mind, like in the work of Salvador Dalí and René Magritte.

Today: Artists work in collage, paint, ink, graffiti, and digital, often drawing inspiration from the past.

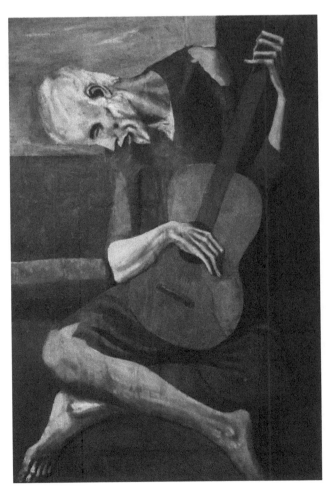

The Old Guitarist by Pablo Picasso

Let's draw in the style of ancient Greek pottery:

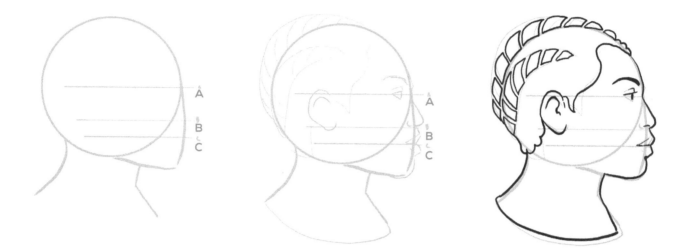

1 With an orange pencil, draw a basic head shape with *ABC* lines.

2 Lightly sketch the major facial features. The portraits on ancient pottery are very simple, so don't go into much detail.

3 With waterproof ink or marker, draw the outline. Create a decorative hairstyle. Again, keep it simple.

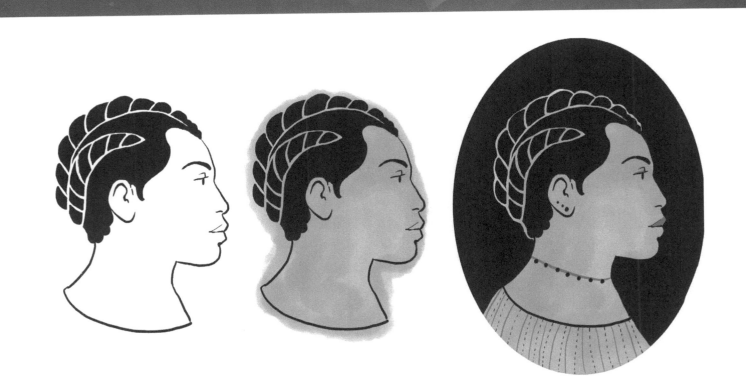

4 Fill in the black of the hair.

5 Color in and around the portrait.

6 Put the portrait in an oval shape. I extended her shoulders and colored the background black. I kept an orange outline around the hair to show off the braid details. Add some decorative lines with a darker orange.

Women outdoors,
attributed to Chrysis Painter Ink,
watercolor, or
colored pencil

Now that we've tried one together, practice a few on your own. Remember, it doesn't need to be perfect. Have fun!

 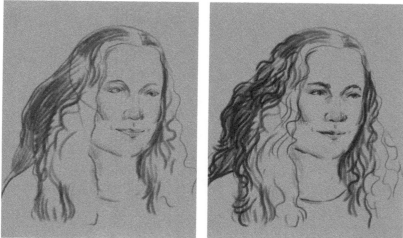

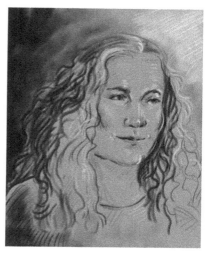

Pencil or charcoal, white chalk, and tinted paper

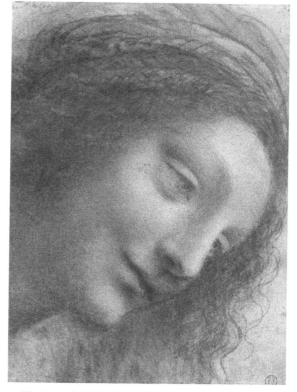

The Head of the Virgin in Three-Quarter View Facing Right by Leonardo da Vinci

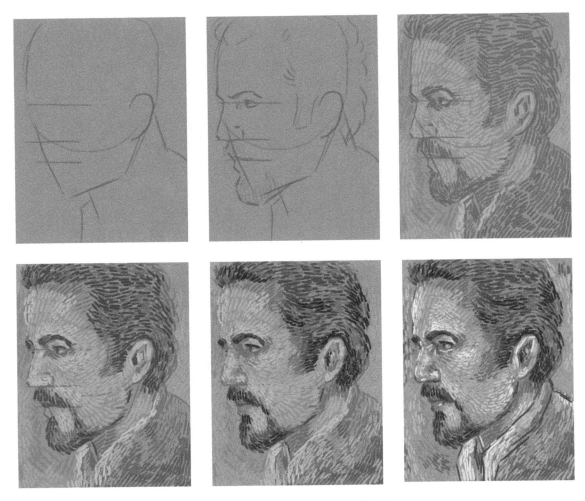

Chalk on brown paper or pastel paints

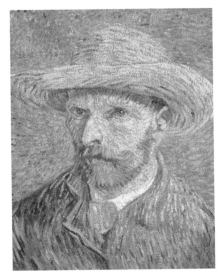

Self-Portrait with a Straw Hat
by Vincent van Gogh

The Modern Selfie

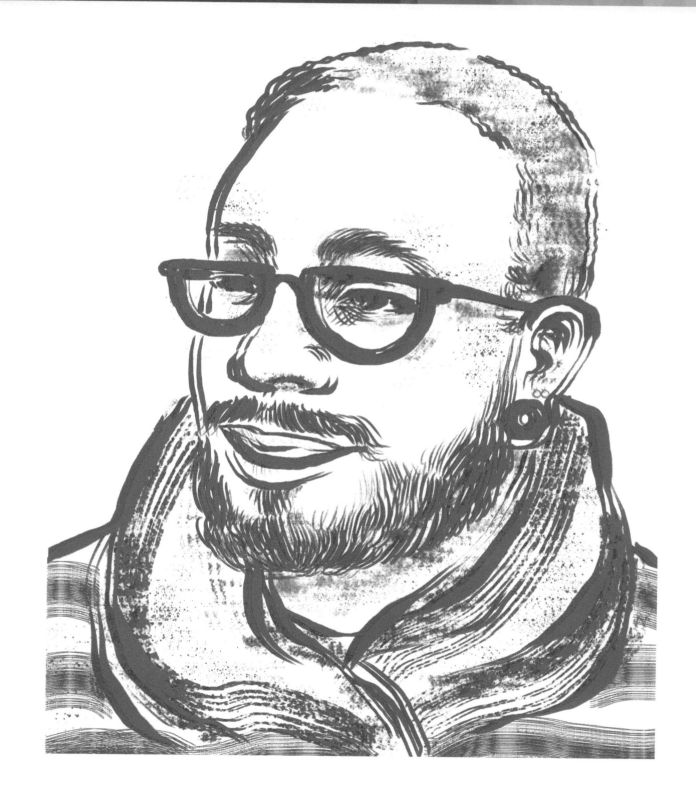

Contemporary artists have a wide range of visual styles. Andy Warhol drew **graphic** portraits with pops of color. Chuck Close made grids and placed tiny patterns within each square, which from a distance form a portrait. Kehinde Wiley creates intricate and detailed patterns with portraits bursting from them. Amy Sherald plays with both color and **grayscale**, and Ralph Steadman uses quick, loose ink strokes, often spilling ink and paint over his canvas to make excitingly wild pieces. Yuko Shimizu's pieces are a blend of traditional Japanese illustration and modern-day comics.

So don't worry about being perfect! Let's use new materials, like paint, watercolor, and pastels, and have fun with color. You want to make your portrait's hair blue? Do it! If you're looking for inspiration, now's the time to break out your phone and turn on those filters.

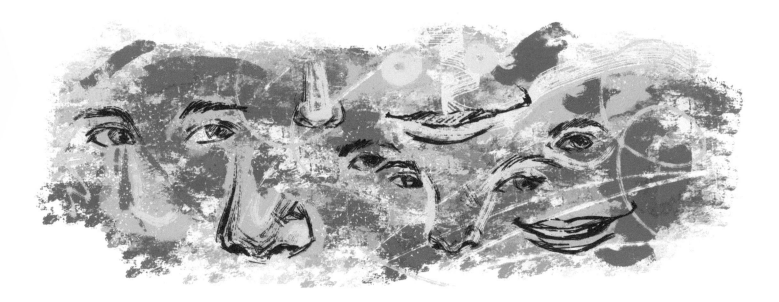

Try It Out

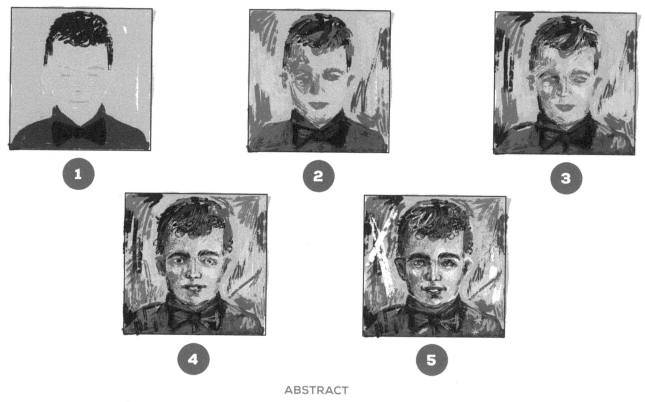

ABSTRACT

Canvas or board base, acrylic paint, brushes, water, and paper towels

1 Gather a mix of acrylic paint; a canvas or board made for paint; large, medium, and small paintbrushes; paper towels; and a cup of water. Cover the floor with newspaper, and paint the basic shapes of the head and outfit and a solid background.

2 Use a medium brush to begin the facial features. Think of areas in shadow as blues and purples and highlighted areas as yellows, oranges, and reds. Do some **drybrushing** to create textures. Clean your paintbrush by dipping it in water and wiping it with a paper towel when you switch colors. Smear extra color from your brush onto that abstract background.

3 Keep adding color and build up the face. Use big, loose brushstrokes.

4 Use a medium brush to keep building colors and form. Add to the facial features. Increase the highlights and shadows.

5 Using the smaller brush, add details. Use a dark color to draw some clean lines for the facial features. Add highlights of white and red for some "pop." Flick the brush to splatter some random dots!

Now that we've tried one together, practice a few on your own. Remember, it doesn't need to be perfect. Have fun!

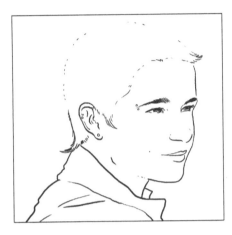

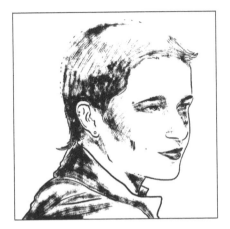

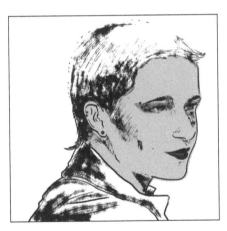

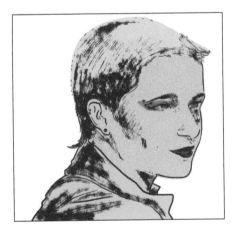

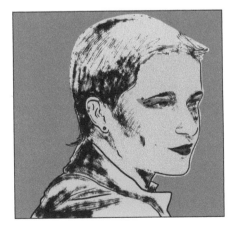

WARHOL

A dried black marker, a regular black marker, and colored markers

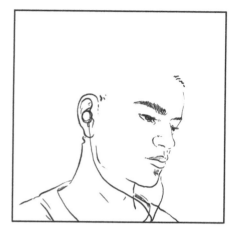

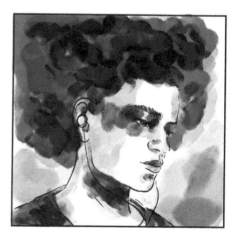

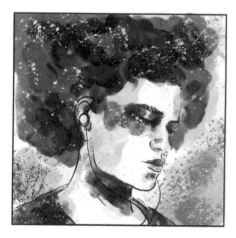

WATERCOLOR
Waterproof ink, watercolor paper, watercolors, brushes, water, and paper towels

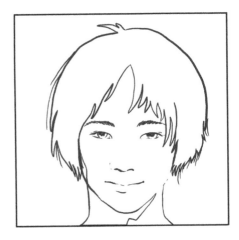

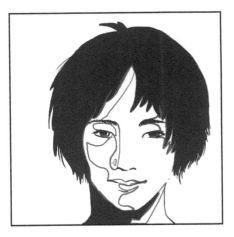

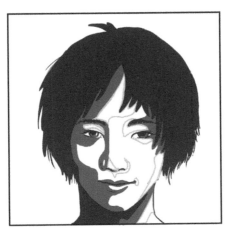

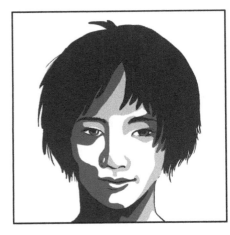

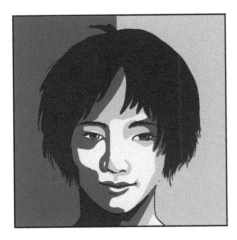

POP ART

Canvas or board, acrylic paint, brushes, water, and paper towels

Group Portrait

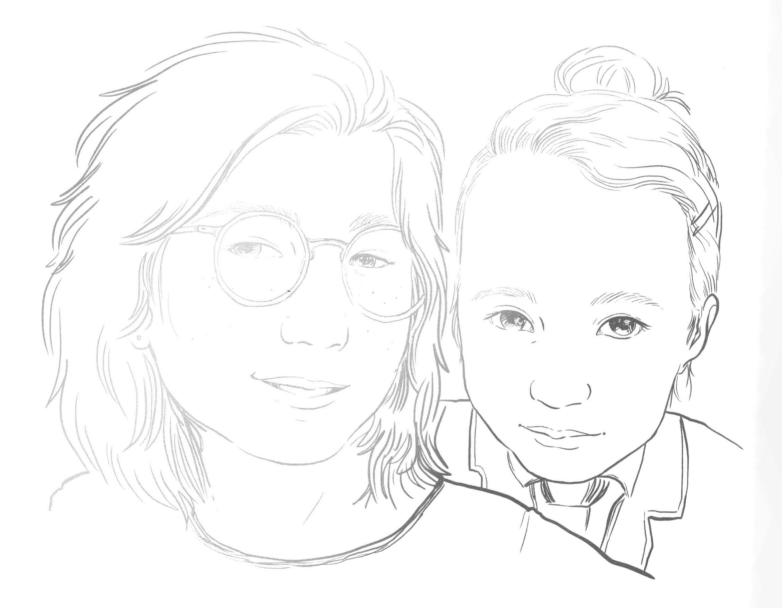

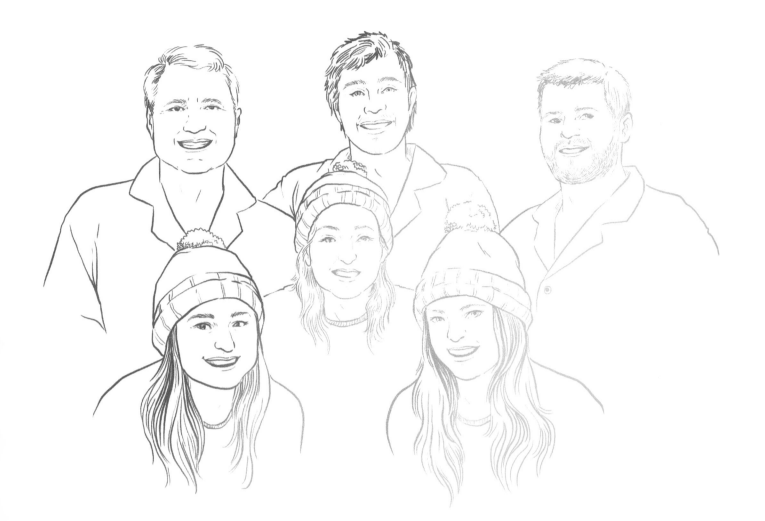

Group portraits need a bit more planning than portraits with an individual. Start by lightly sketching everyone first, and make sure you position them in a nice arrangement on your paper. You don't want to squish them all together or draw them too small. When sketching, lightly draw ovals for their heads and arches for their shoulders; that way you can quickly draw and erase until your piece looks right to you. Once you've finished that, you can place your *ABCD* lines. Finally, I suggest drawing each portrait one at a time.

For this activity, I recommend using a photo for reference. It's easier to have it on hand than to try to pose everyone as an individual or pose the group for a long period. Keep backgrounds simple to focus attention on the faces.

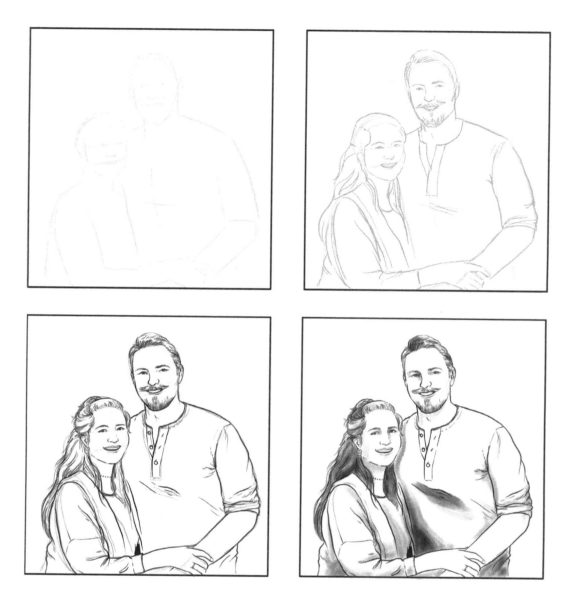

1 For each individual, start by blocking in the basic shapes of the head and upper body very lightly with pencil. Sketch where the eyes, nose, and mouth will go.

2 Sketch slightly darker the details of the hair, clothing, and facial features.

3 With ink, start finishing the portrait and body of one figure. Then finish the other figures.

4 Erase the sketch and add any final details and shadows.

Now that we've tried one together, practice a few on your own. Remember, it doesn't need to be perfect. Have fun!

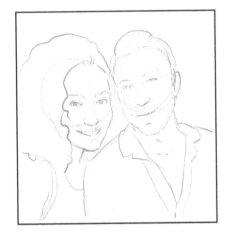

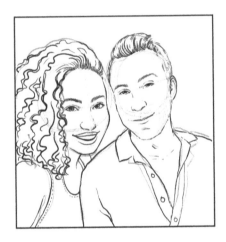

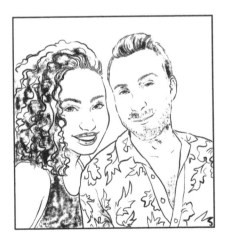

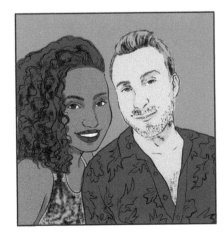

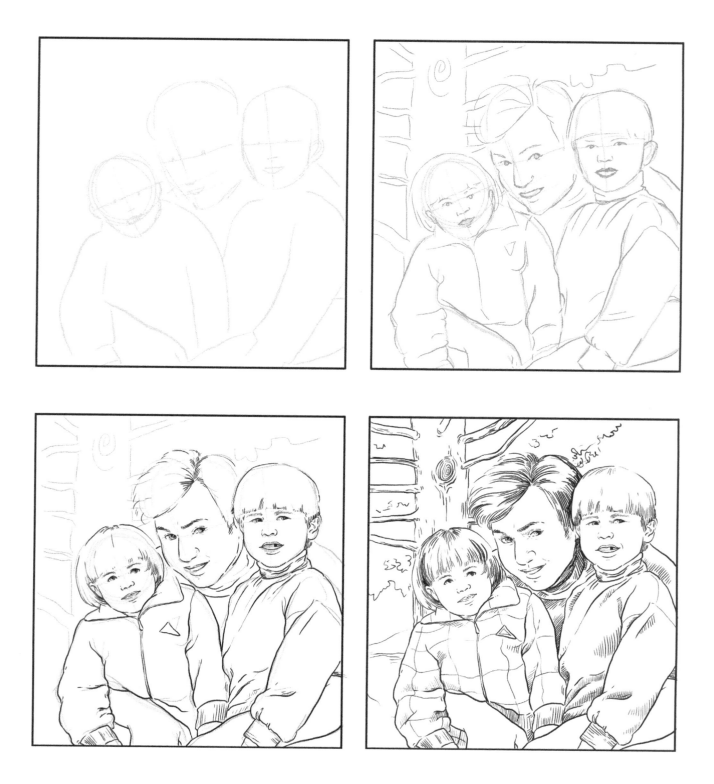

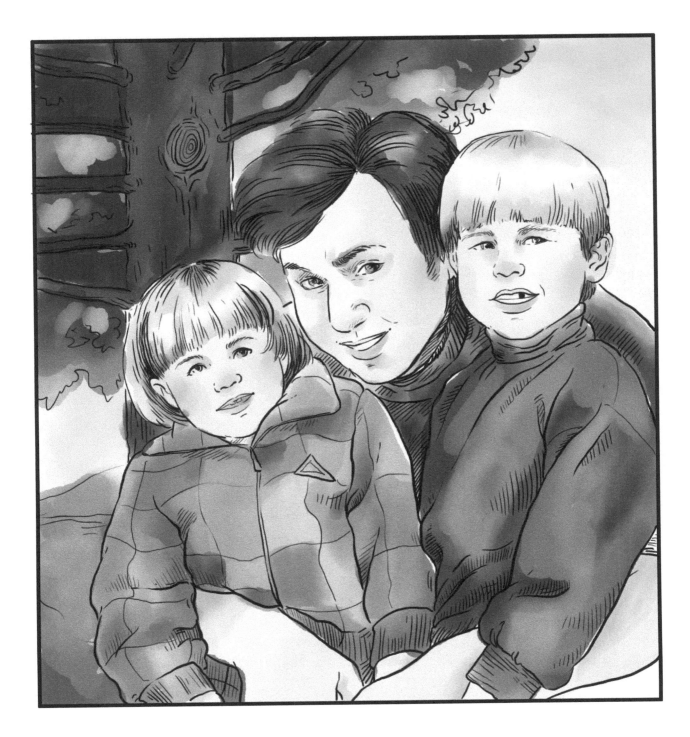

FURTHER READING

Anatomy of Facial Expression by Uldis Zarins with Sandis Kondrats. This book delves into the individual muscles of the face and how they're connected and goes very deep into how that impacts expressions.

Art: Over 2500 Works from Cave to Contemporary by Nigel Ritchie. A great collection of art and different styles throughout history.

Artists: Their Lives and Works by DK and Ross King. A collection of artists and their self-portraits, showing different selfies over time.

Authentic Portraits by Chris Orwig. Do you have a lot of fun taking photos of yourself and other people? This book goes into detail on capturing someone's soul and character through photography.

Drawing the Head and Hands by Andrew Loomis. An oldie but a goodie. Loomis teaches some classic academic lessons on portraits but goes into detail on matters such as facial structures.

How to Draw Comics the Marvel Way by Stan Lee and John Buscema. Take what you've learned in this book and apply it to making your own comics full of superheroes and villains.

Modern Art: A History from Impressionism to Today by Hans Werner Holzwarth. See some of the more modern and abstract ways artists in recent history have made portraits.

Norman Rockwell: 332 Magazine Covers by Christopher Finch. Rockwell was an iconic painter who captured memorable stories in his characters.

Portraits: A History by Andreas Beyer. A great collection of the different ways portraits have been made throughout art history.

The Artist's Complete Guide to Drawing the Head by William Maughan. For more advanced portrait artists, this book goes into drawing realistic portraits using just form and value.

The Atlas of Beauty: Women of the World in 500 Portraits by Mihaela Noroc. If you really love photography or just want to be inspired by the diversity of the world, this book captures the portraits of 500 women from across the globe.

INDEX

ABOUT THE AUTHOR

Angela Rizza graduated from the Fashion Institute of Technology in New York City in 2011 and since then has been creating artwork in Mahopac, New York. Her work is inspired by the wildlife around her home and her favorite childhood stories. She enjoys teaching art and creating activity books that help others learn and use their imagination.

Printed in the USA
CPSIA information can be obtained
at www.ICGtesting.com
CBHW040512C10224
3921CB00003B/24

9 781641 527255